BRAVE BIRDS

Inspiration on the Wing

Maude White

abrams image, new york

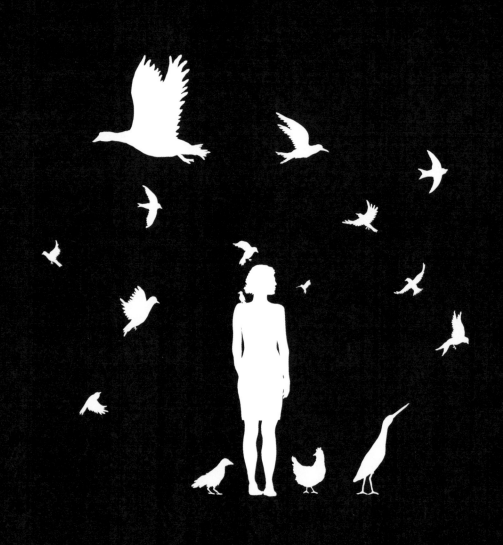

BIRDS I'VE BEEN

I have loved many birds in my life. Loved the abstract notion and existence of birds as much as the physical, tangible birds themselves. Often, the sight or sound of a bird has given me both bravery and hope.

My love for birds has not always been particular. There are birds I have loved without knowing their names and birds I have loved for the beauty of their song alone. Sometimes, all I have needed from a bird has been the flicker of its body, the connection through sight with a creature unbounded by the physical earth. I have always felt that looking upward instills hope in those of us tethered to the ground.

At other times, I have gained strength and encouragement from a specific bird, finding it out in the world, in literature, and ultimately in my own body, as I recognized those same instincts and skills that I so loved and admired within the bird.

I am a language person, a word person. Words hold power, both alone and together. In its simplest definition, a bird is an egg-laying, feathered vertebrate. But as happens so often with language over time, *bird* has also come to refer to both a human female and a human of either sex possessing peculiar or interesting characteristics.

The usage of the word *bird* to refer to a woman dates from the beginning of the twentieth century. Independent of that most recent appropriation, there is an older, Middle English word *burde* that originated in the 1300s to refer to a young female. That this old, forgotten word has been resurrected in usage and meaning in our present world both fascinates and moves me.

Unfortunately, this current habit of referring to a woman as a bird grants little respect to the woman in question. The term implies overfamiliarity and dismissiveness. This surprises me. After all, birds possess beauty, strength, intelligence, and a wild and powerful will to survive. They connect us to the sky and the water, realms that we, as humans, cannot ourselves easily traverse. Birds evolved from dinosaurs! How can one not feel awe and respect?

As with the word *bird*, I am strongly drawn to the word *brave*. By definition, bravery is generally defined as having or showing courage.

I believe the word *bravery* should be used more often. In today's language, the word seems to refer to the absence of fear or to physical or dramatic acts of heroism, making *bravery*, as a concept and a personal experience, impossible for many of us to ever truly embrace or believe we have achieved. But I believe that myriad small, everyday acts require bravery and strength and should be honored, celebrated, and appreciated.

The *Brave Birds* idea grew from my wish to claim and reclaim our current cultural definitions of both *bird* and *bravery*. My love for birds knows no constraint. It is a welcoming, hungry passion that requires neither understanding nor complicity from the birds themselves. My identification with birds and my reference to us all as brave birds arises from the hope that we human birds might someday be able to apply to ourselves the same selfless admiration and love that we feel for literal birds out in the wild and in the abstract. I want us, as human birds, to be able to feel passion and understanding for ourselves. I want us to love and experience the simple wonder of *our* existence, just as we love without judgment the existence of the physical birds we see and hear out in the world each day. In this way, I believe that we are all brave birds.

Early in 2014, I was attacked. As I healed and recovered, I began drawing and cutting a great blue heron. During that time I was afraid to leave my home. I was afraid of the darkness. I was afraid of my own memory and my lack of memory.

As I carefully drew and then cut each feather on the great blue heron, as I studied and moved around my giant bird creation, I began to feel as if the heron I was creating was simultaneously becoming a part of my body, investing me with those qualities I admired and loved so much. To this day, I cannot see a great blue heron without feeling a surge of love and gratefulness. During my recovery, that heron was my friend, my doctor, and I held his essence in my body as I healed. He was my bird, my concept of safety and strength.

Five months later I was mugged. The mugging occurred in the daytime, and soon I found myself falling not only back into my fear of the darkness, but experiencing new fears of the daylight world as well.

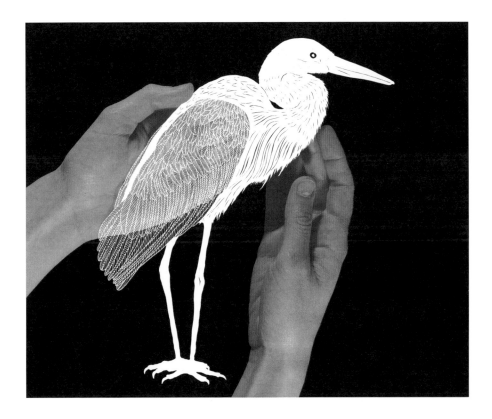

Again, I turned my knife to cutting a bird. This time, I began work on a girl and a crow. In the piece the crow was emerging from the woman's face. I wanted this crow to symbolize the dark and vengeful bird that I wished could come forth to confront any mugger approaching any seemingly defenseless woman. I wanted this wild, ruthless, and savage bird to inhabit my shrinking, hesitant body. I wanted this bird to help me do what I had been unable to: defend myself. The crow was my symbol, my protective confidante. The crow gave me the strength and the courage to leave my home again.

I have been many birds in my life. I have been a hummingbird, flying backward into the past. I have been a barn swallow, quick and sure in decision and strength. I have been a great blue heron, patient and still in recovery from pain and fear. I have been a crow, observant and watchful as I questioned decisions and hesitated on great brinks. Birds, like humans, are many things. They are ruthless. They are collaborative. They are deceitful. They are loyal. They give gifts. They mourn. Some birds solve problems, some think analogously, some create new, recursive speech patterns, and some craft tools.

As I cut the brave birds collected in this book, I found myself learning more about each kind of bird. I began to ask myself, what can this bird teach me? What strength and self-assurance can I gain by recognizing within myself those survival strategies that I admire so much in this bird? I began to apply aspects of bird behavior, strength, and power to my own life, and this has given me comfort and strength and helped me through some very difficult and confusing times.

There is a great deal about birds that I do not know. I have found myself wondering, can we love something that we do not understand? Do we have the right to experience love for something we do not understand? The answer is a resounding *yes*.

I realize that in some respects, our love can only be heightened by our lack of knowledge. We can love the potentiality of birds, love the great, swooning idea of *discovering* knowledge just as much as we love the concrete knowledge we possess now.

I do not know whether birds have moral codes of behavior. I do not know whether they experience grief or happiness. I do not need to know the answers to these questions. My love is not contingent on moral affinity. Just so, I do not need to understand myself or my fellow human birds to recognize that we are all valid beings and we are all worthy of an attempt to be understood and respected.

Birds have taught me many things. Most importantly, they have taught me that love grows. They have taught me that if we allow ourselves to love without judgment or expectation, our love will expand and keep expanding. We can find ourselves loving beyond our own understanding, beyond our own safe borders. And love is never the wrong decision.

I believe that we are all connected, that there are ties that bind all creatures and creations together. Because of this, I believe that all actions, all kindnesses and comforts can have an impact beyond our understanding. I hope that my words and work here can encourage you to give comfort and kindness to yourself and to others. There is always room for kindness. There is always room for hope.

May the brave birds I have created give you strength. May they show you paths you might have missed. May they give you confidence. May they help you recognize and express love. May they teach you to be resilient. May they remind you that there are many ways to be intelligent and many ways to thrive and create in the world. May they encourage you to persevere. May they show you the wondrous connective power of kindness and empathy.

Love,

Maude

1

BIRDS
for
JOY

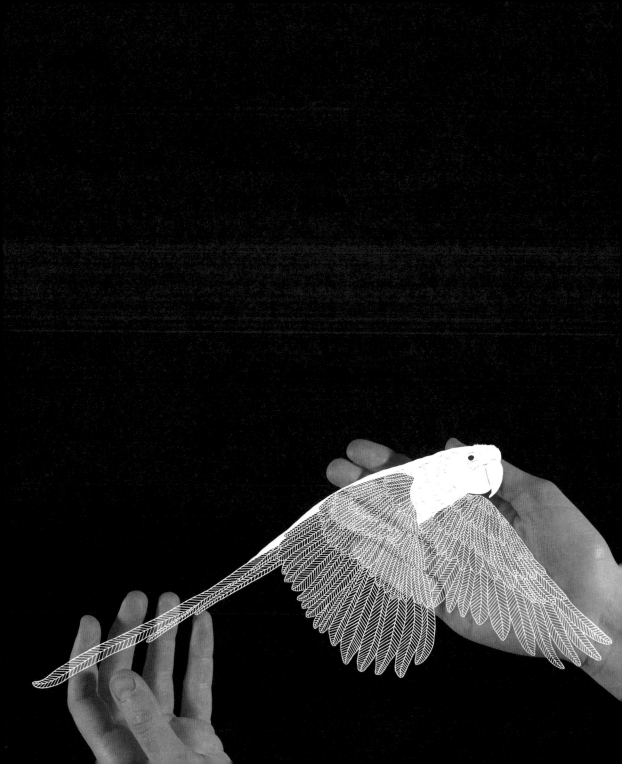

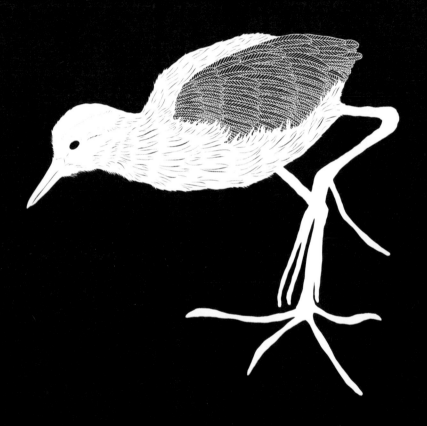

the jacana

Step lightly, brave bird! There is much to rejoice in! The wading jacana is so swift and skillful on her long, slender legs, that when she moves it often appears as if she is walking upon the water. She does not allow the fear of sinking to deter her, but instead steps quickly with surety and grace. Embrace your own spontaneity and build your confidence, jacana. Do not doubt that as you move forward, you are moving in the right direction. Do not stop or take pause to second-guess yourself. You are going far!

the bowerbird

The bowerbird knows that just as we shape and influence our environment, we are also shaped and changed by the places we inhabit. When a bowerbird creates his bower, he chooses each rock and piece of grass, each found treasure, with exquisite care and passion. He spends days arranging and rearranging his surroundings, not satisfied until he finds the perfect combination of color and light, perspective and depth. Never stop creating spaces that make you happy, dear bird. We are all artists. Creating beauty brings us joy. Create for yourself a bower that satisfies your soul.

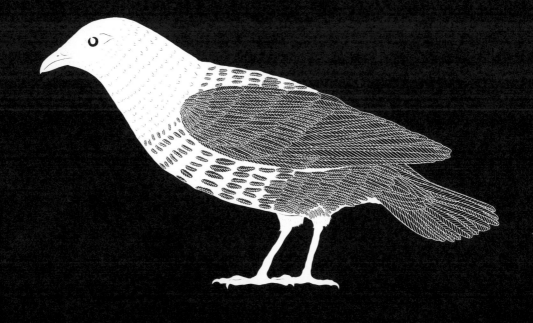

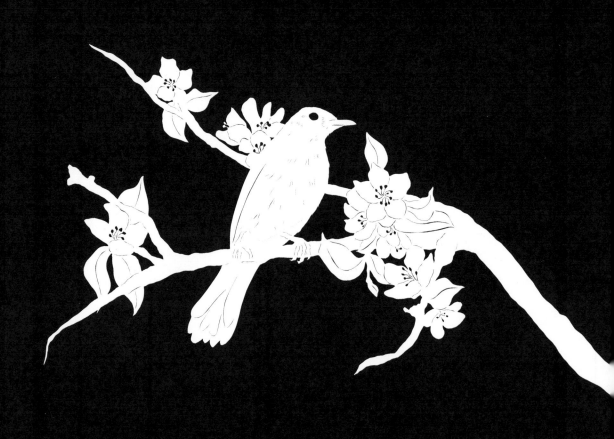

the gray catbird

The gray catbird invites us to speak and to take advantage of the beauty of language. Dear catbird, have you written anything lately for the pure joy of it? Or have you read aloud a love letter or created poetry just for yourself? Like the mockingbird, the catbird mimics the songs of others, but unlike the faithful mockingbird, the catbird cleverly recombines his songs and notes to create new and unique music. Explore how you can use language not just as a vehicle for communication but also as a creation of passion. Remember what it feels like to speak for the sake of beautiful words. Find joy in the enchantment and magic of language.

the skylark

We rise and we fall. There will be ups and downs in life. The skylark knows this. He embraces and welcomes both the highs and the lows as his flights take him spiraling upward and then swiftly down to earth. Throughout, he never stops singing. There is wisdom to be gained in this. Feel and speak of both your happiness and your sadness, dear one. Do not let your fear of falling into deeper sadness stop you from going out into the world and searching for higher happiness. Live for the present moment and find the meaning in each day as it comes.

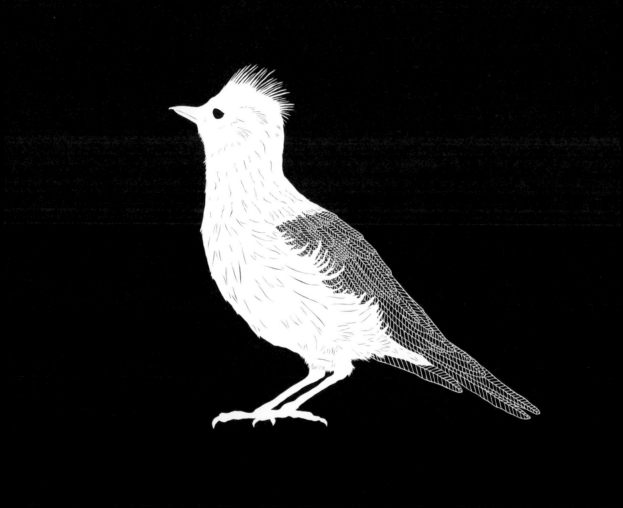

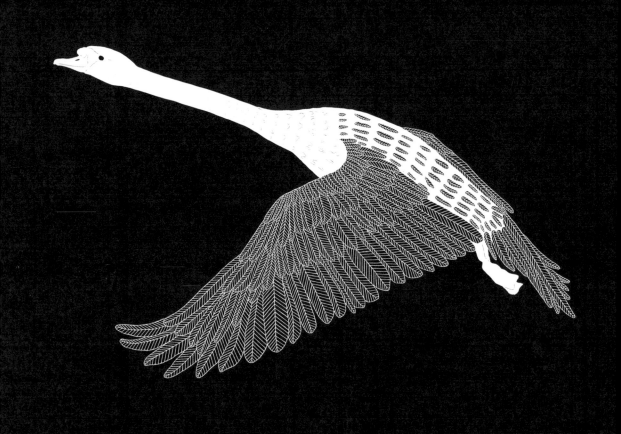

the swan

The swan knows that each one of us has many roles to play in life. She is regal and fierce, and yet, her very stateliness makes it difficult for her to take flight and to return to land. She is possibly the heaviest bird capable of flight. She can only gain the air from the water, and her takeoffs and landings can be both messy and comical. The swan teaches us that we can be many things. What is important is embracing all that we are with style and grace. Brave swan, allow yourself to inspire and embrace both the respect and the laughter of others with joy and gladness.

the macaw

Parrots, like crows, are highly intelligent birds. A long juvenile period for both species contributes a great deal to cleverness and quick problem-solving skills. Macaw parents are very devoted to their offspring. They stay with their fledglings for years and often do not start new families until they are confident that their young will survive on their own. This gives the fledglings the freedom to learn, to play, and to experiment. For any bird, animal, or human, the freedom to spend time playing is very important. Dear macaw, make sure you take time off from work. Remind yourself that playtime is not wasted time; it is a healthy release of energy. Give yourself time off to relax and have fun. Be joyous! Let go of your responsibilities and your worries for the future and let yourself be present and carefree. Remember the games you loved as a child? Remember the excitement of make believe?

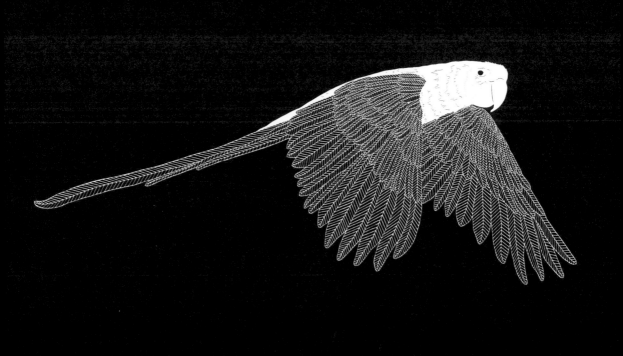

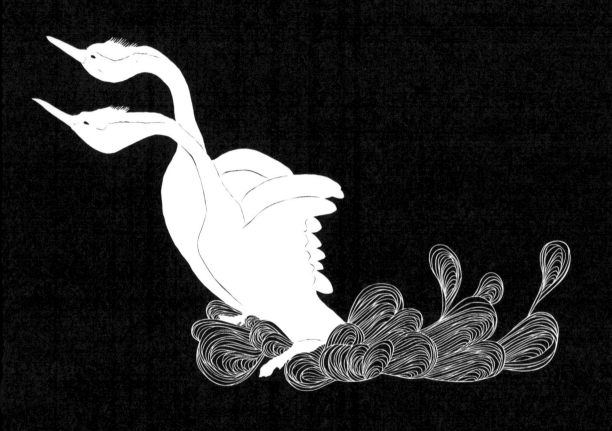

the great crested grebe

Brave bird, have you opened yourself up to the joy of spending time with another? The great crested grebe knows the importance of trust between partners. Each step of a pair's glorious mating ritual must be perfectly timed and prepared, must be practiced with patience and assurance. They must trust each other. Take joy in the body and mind of your partner, brave bird. Yes, relationships take a great deal of time and effort, but remember how beautiful the rewards are! Do not be afraid to invest yourself. Do not be afraid to take the time to learn how to move together with the one you love.

2 | **BIRDS**
for
CREATIVITY

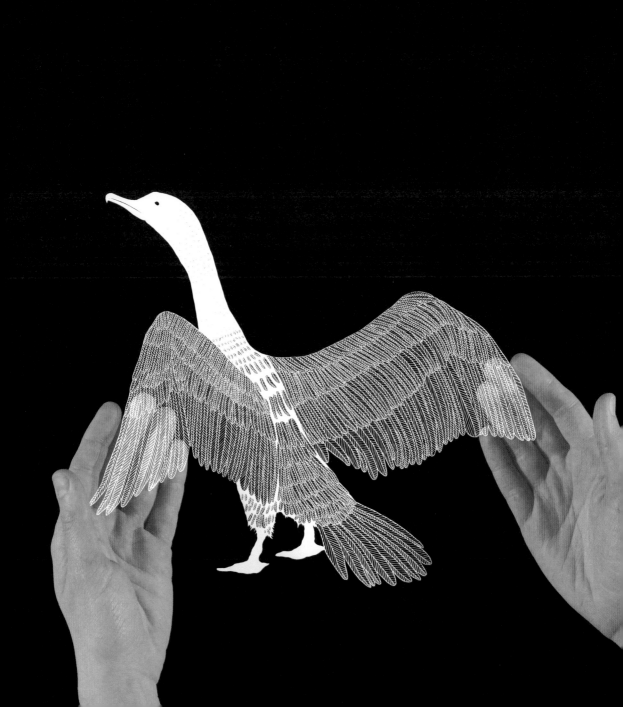

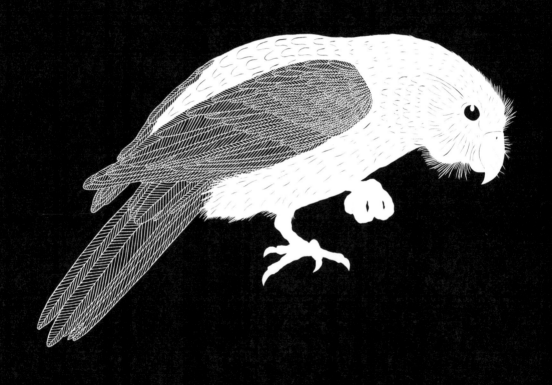

the kakapo

It takes a great deal of energy to fly. But for the majority of birds, flight is what makes survival possible. The only flightless parrot in the world, the kakapo is one of the most creative and innovative birds when it comes to problem-solving. Although her wings cannot support flight, she cleverly finds ways to use them for balance when climbing trees to reach fruit and for gliding expertly back down to earth. She travels long distances on foot along the forest floor, undeterred by her inability to fly. She has evolved into a nocturnal bird, having found that there is safety in the darkness when daylight predators sleep. She is perhaps the longest living bird. Dear, are you looking at all of the ways to solve a problem? The kakapo shows us the value of alternative solutions. Sometimes a bit of creative thinking and openness to new options can reinspire and renew us.

the nuthatch

The nuthatch knows that many unexpected discoveries are made when you let curiosity lead you. She never stops investigating and unearthing what is often just beneath the surface. She is an eager, inquisitive, and agile bird who examines her domain from every angle—oftentimes upside down! Pay attention to her, brave bird. She is inviting you to explore. She is reminding you to never stop looking around and investigating what you find. Creativity and new endeavors often grow and expand when you let yourself explore. And just think, you may discover things that others missed! May you dig deeper. May you learn with great joy.

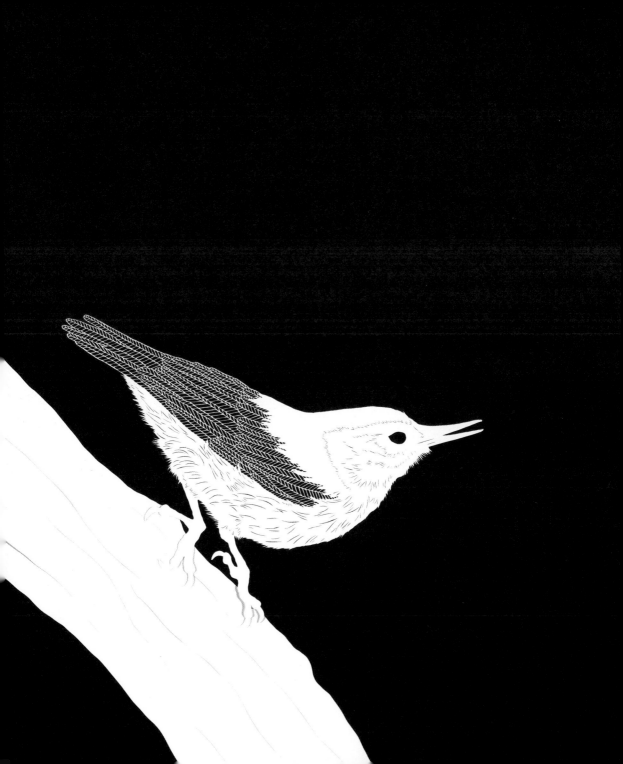

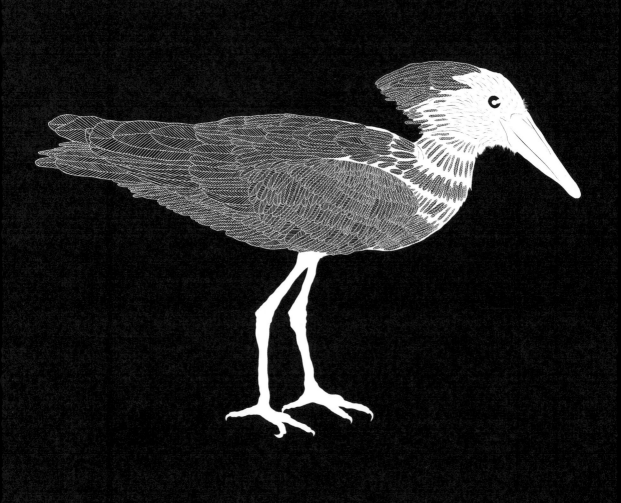

the hammerhead

The hammerhead knows how important it is to build a home that feels just right. Couples create fantastic and elaborate nests out of tens of thousands of sticks, adding whatever brightly colored objects are close by. But the couple doesn't stop there. They build multiple nests every year, abandoning and moving on whenever the mood strikes them. Is the hammerhead speaking to you, dear one? Is it time to start building something new? If home doesn't feel right, perhaps it is time to try again. You can reimagine and recreate home as many times as you need to. After all, sometimes the healthiest thing to do is to start over. Just keep building! As the hammerhead knows, you don't have to be a master builder to create a beautiful space. You can make a home out of all sorts of things.

the red crossbill

Don't be afraid to take it slow and explore, brave bird. Give yourself time to find the perfect place to fit in. As the red crossbill knows, there is a place that will suit you. Keep looking! The unique crossed mandibles of a crossbill are specially shaped to pry open conifers and extract the hidden seeds. But not just any conifer will do. Many crossbill mandibles are so distinctly individual that different birds are only able to open certain species of conifer cones. Find the activity that suits your unique skillset and creative mind, brave bird. Don't let yourself settle for anything less than what makes you feel completely comfortable. Remember, there are many small but valuable ways to adjust and tweak your life in order to find deeper satisfaction. And sometimes, tasks that seem difficult can be enjoyed if you let yourself approach them from a new and more creative angle. Are you trying to open the wrong conifer, crossbill?

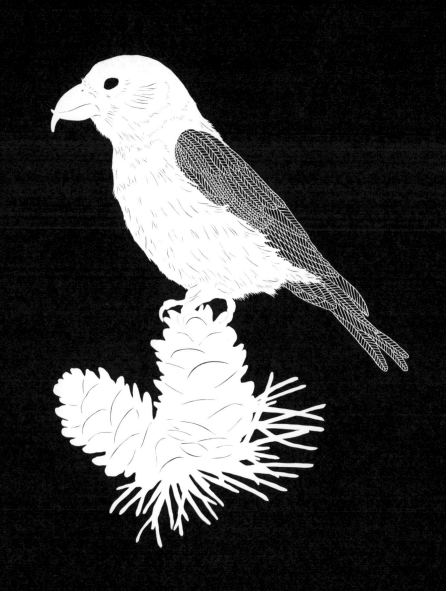

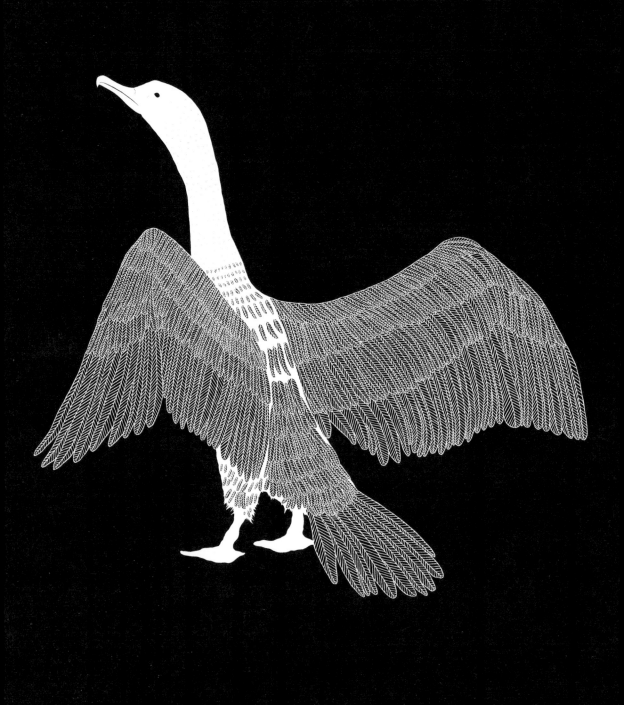

the cormorant

The cormorant knows how important it is to create boundaries. Although she is a nimble fisher and a skillful diver, she does not spend all of her time in the water. When not hunting for food, she prefers to stay on shore, preening and basking and congregating with others in the sun. To her, the water is a place for work, not for enjoyment or relaxation. Don't be afraid to create boundaries for yourself, dear one. Do what you can to maintain a balanced separation between home life and work. Otherwise, you may never truly be able to relax and enjoy yourself. And you deserve some enjoyment!

the bluebird

Dear, do not be afraid to reuse ideas, to let others inspire you. You do not always have to start at the beginning. The bluebird knows how important it is to be resourceful and to make use of what is already being offered by others. She does not build her own nest and as a result is susceptible to loss of habitat. As land is cleared she is deprived of tree cavities and other natural home sites. She must depend on human-made birdhouses or empty woodpecker nests to raise her family. Brave bird, don't forget how important it is to use the skills and tools that others have left you. Like the bluebird, you have the power to make something fresh and new from what has already been created by others.

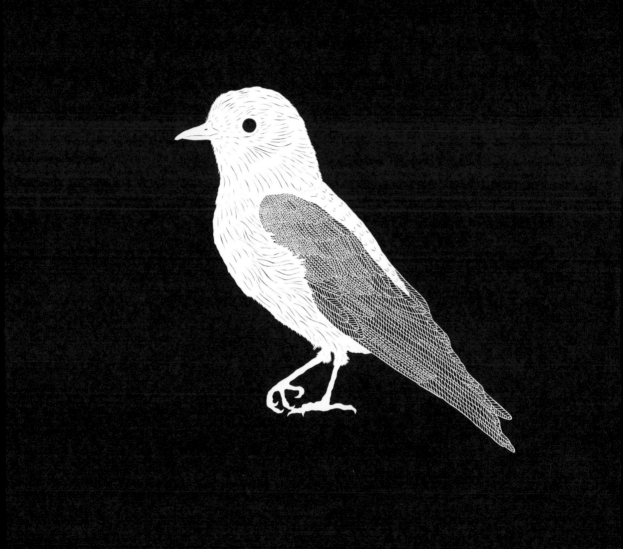

3 | BIRDS
for
PATIENCE

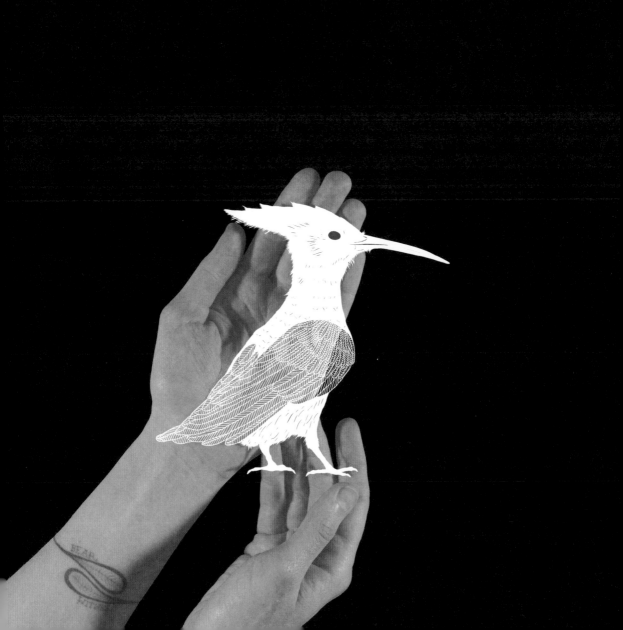

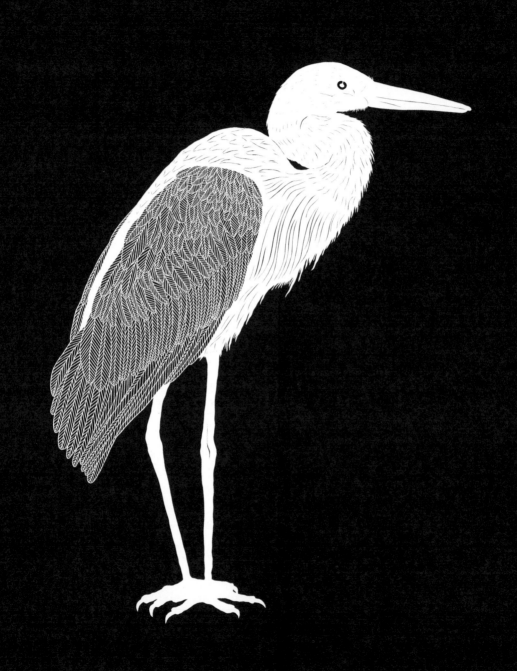

the great blue heron

There is a reason that they call a group of herons a siege. Can you guess why, dear one? Herons have mastered the art of stillness and patience when hunting. Do not be afraid to take your time, brave bird. Before you act, consider and weigh all of your options. Like the heron, use your eyes and observe. Allow yourself to adjust to information as it comes and do not act before you're truly comfortable and ready. Have patience with yourself. Remember, we all learn and move at different speeds.

the hen

Dear bird, is there something you've been brooding over? An idea or a problem that you've been pushing aside that just keeps coming back? Perhaps it is time to sit yourself down with the problem and devote all of your attention to working it out. When a hen feels it is time to hatch a family, she is said to go *broody*. She will become entirely focused on laying and protecting her eggs, ignoring all other birds or impulses. She will often forget to eat, drink, or forage with the other hens, and she will guard her eggs fiercely. Brave hen, if you feel the need to brood deeply over an idea, do not fight the impulse! Do not try to force your thoughts or energies in directions your heart does not wish to go. Your ideas are precious. They are your creations. Let them take form.

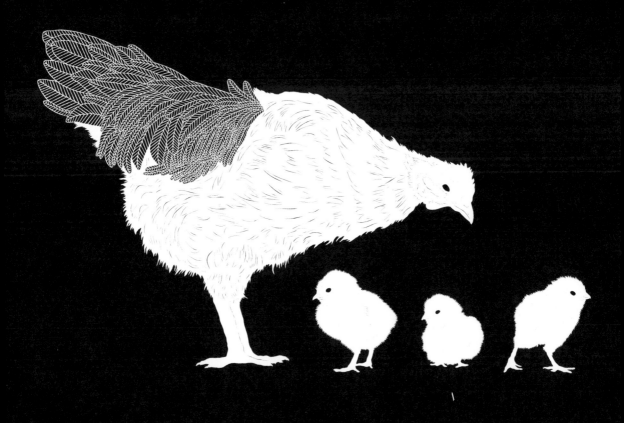

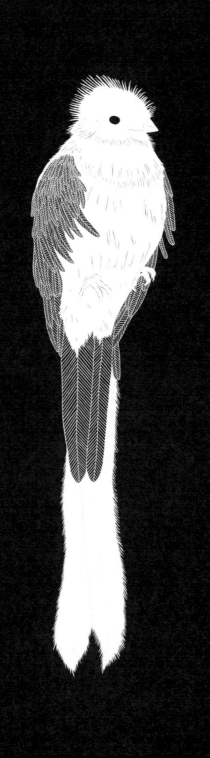

the resplendent quetzal

The resplendent quetzal is considered one of the world's most beautiful birds and was revered as sacred by the ancient Mayan and Aztec civilizations. He is primarily a fruit eater and his great appetite for avocados leads to the dispersal and growth of new avocado trees. Dear bird, every relationship is a delicate balance of give and take. Every little action and every kind word may have meaning beyond your understanding. Be patient as you discover what you've given and what you've gained. Some rewards take time to materialize, but that doesn't make them any less meaningful or impactful. You never know what you may end up offering to others or what you may learn from them. Make sure your relationships and interactions are mutually satisfying. May you be willing to learn and also to teach.

the carolina parakeet

The Carolina parakeet was the only native North American parrot. Before extinction, the vibrant green and yellow feathers of each bird could be glimpsed in many Eastern forests. Today, she is gone, having lost her habitat and been hunted to extinction for her bright feathers. Brave bird, may we be patient and learn the lesson she is teaching us. Together, let us try to appreciate and love beauty as it comes to us and then let the beauty go when it asks to leave. Let us work to honor what we adore without caging or possessing it. Let us also protect ourselves from being caged and loved in such a way. May we be patient with what we find in the world. May we be thoughtful and restrained when we feel the urge to acquire what we yearn for. Instead, may we celebrate the knowledge that sometimes the most important way to honor another creature is to let it go free without trying to possess its beauty.

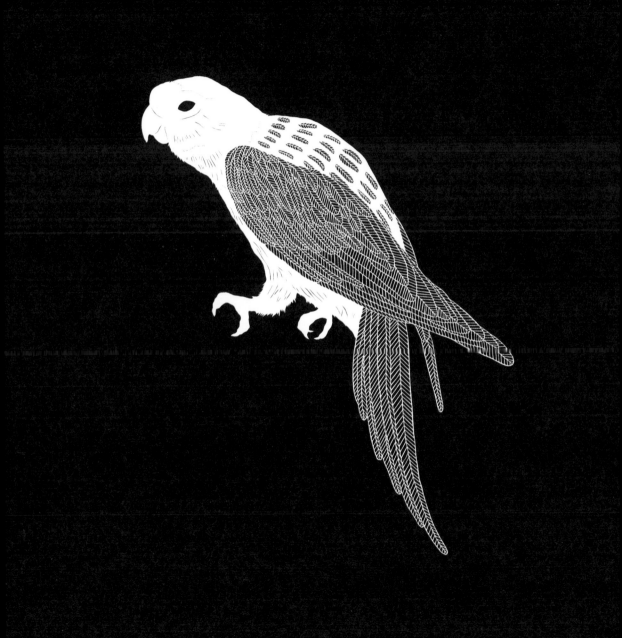

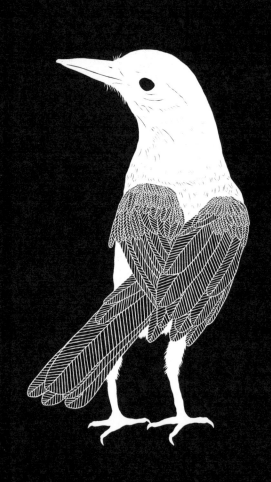

the scrub jay

The scrub jay knows how to plan for the future. She has an incredible memory. She spends each day planning for the seasons ahead by collecting nuts and seeds and burying them to eat later. She is capable of remembering up to two hundred hiding places and in what order her food must be consumed before it becomes inedible! Dear one, have patience. Recognize the wisdom of planning ahead and saving some goodness for the future. Don't expect to have everything all at once. Know that some things take time, and some ideas need patience and space to germinate.

the hoopoe

The hoopoe's powerful beak is both a tool and a weapon. He uses it to forage and probe the earth for food and to defend himself from others. Like the hoopoe, we can use our mouths to utter words that both nourish and inflict pain. Your voice can be a weapon or a balm, brave hoopoe. Think before you speak, and take time to reflect. Your voice can offer great kindness. May you use your voice well. May you be patient with yourself and with others.

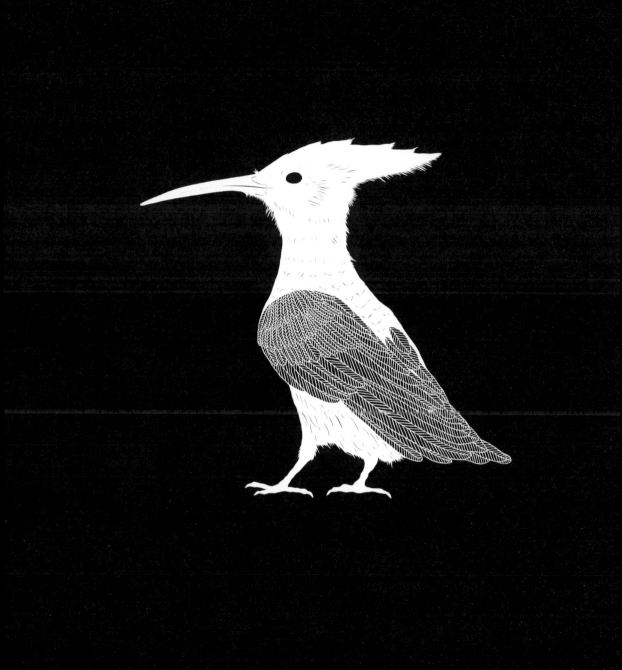

4

BIRDS

for

KINDNESS

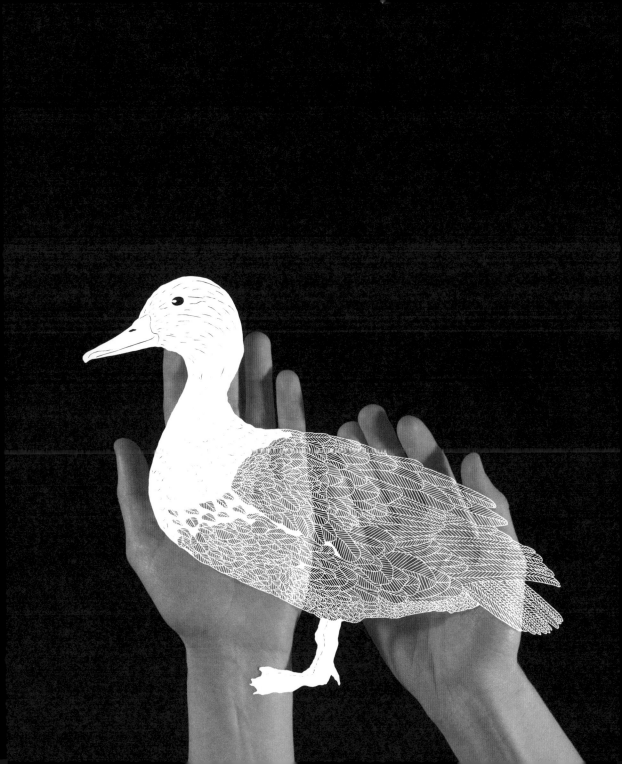

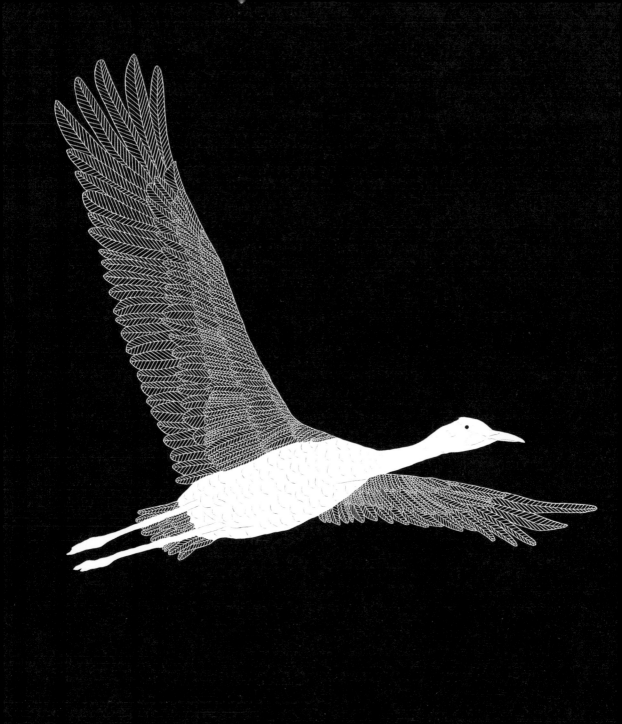

the crane

We all carry our own personal journeys within us. Because of this, because we all have a unique perspective to offer, there is always an opportunity for us to learn from or to teach others. The crane learns her migration route from her parents. She cannot find the way herself but must accept guidance and direction. Like the crane, we must be patient with ourselves and with others and be willing to learn and to guide. Dear crane, open yourself up to the wondrous give and take of knowledge shared and received! Do not become impatient with yourself or with others. Teach with kindness. Learn with eagerness.

the oilbird

The oilbird is a mysterious and elusive bird of the night. She roosts in caves and is the only bird to find her way in the darkness by echolocation. The oilbird asks us to be conscious of the give and take of action and reaction, of cause and effect. The oilbird finds her way by the reflected sound of her own voice. Send out into the world what you hope to receive, brave one. Be conscious and be kind to those you meet, and you will receive conscious kindness in return.

the magpie

The magpie possesses the gift of self-recognition. She has the ability to recognize herself in mirrors and therefore possesses a sense of her own uniqueness. This is an important gift because it allows her to be conscious of her own identity as separate from those who surround her. It allows her to recognize the impact she can have on those whom she meets. What an immense and satisfying power! She has the ability to find happiness and satisfaction in the happiness and satisfaction of others. We, ourselves, have that power. We can both recognize and celebrate our own identity and recognize and celebrate the unique identities of others. May we recognize one another with empathy and celebrate one another with kindness.

the duck

Baby ducklings imprint on the first thing that they see when they are born. Very often, subsequent relationships aren't about mutual respect or agreement, but instead consist of an illogical urge to emulate and follow without question. Although comical, this can pose problems. What happens if there comes a time when a duckling realizes he is different than his family? To whom can he look for guidance? Have you come to a similar crossroad, brave bird? Have you found yourself at odds with the ones to whom you are close? You can love family and friends and still disagree with them. Recognize that at any point you can reevaluate whom you choose to depend upon and follow. You have the power to decide. There is always the opportunity to create a new family of like-hearted souls. Never doubt that there is a place for you to feel accepted, recognized, and valued for exactly who and what you are. May you find a place where you can give and receive kindness without fear or judgment.

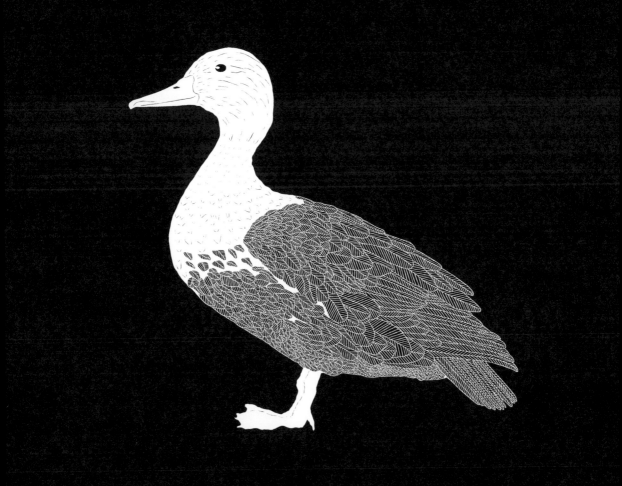

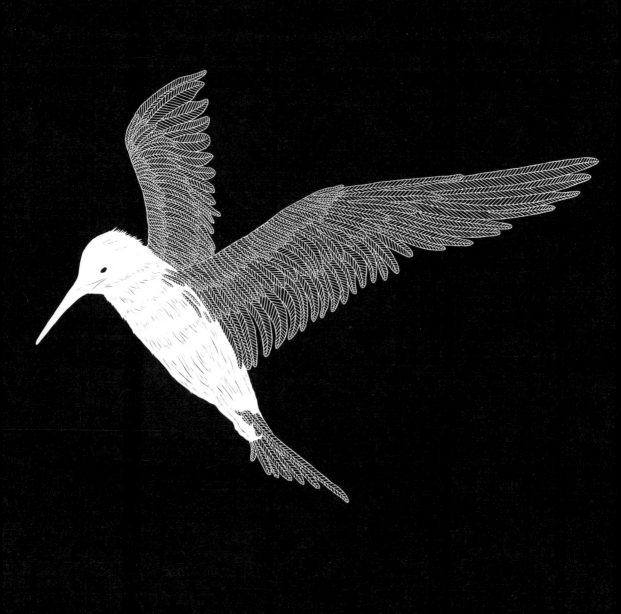

the tern

When you go out into the world, brave dear, give those whom you meet the gift of your attention. Listen to them. Very often, all it takes to make a person feel worthy is the knowledge that there is someone willing to listen and understand. Terns breed in large, noisy, and crowded colonies. Despite the noise and confusion, each tern memorizes the voices of family and friends and can always recognize and find them. Have you listened to the voices of your loved ones lately, dear? Have you memorized the precious sound of affection in another's tone? Sometimes recognition is the kindest gift we can give or receive.

the mountain quail

Brave bird, I want you to feel safe. Ask yourself this ques-
tion: Do the people who surround you, who touch you,
make you feel protected? Does their presence give you
courage? The mountain quail knows the importance of
trusting in the kindness of others. When darkness falls,
mountain quails roost in a circle, tails touching as they
face outward. This is both to conserve body heat and
to preserve physical safety. There is no direction from
which a predator can approach unheralded. In this way,
the mountain quail teaches us that there are times when
we are stronger together. Have you offered your strength
to others, brave quail? Of equal importance, have you
allowed yourself to recognize and accept the strength that
others have offered to you?

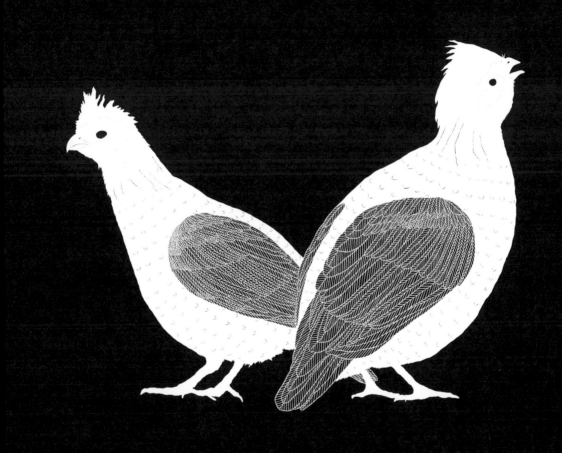

5 | BIRDS *for* RESILIENCE

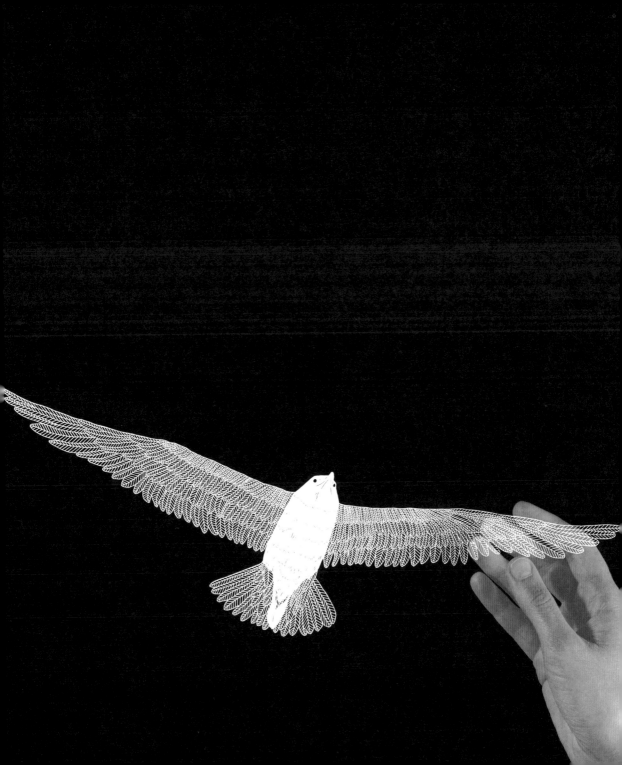

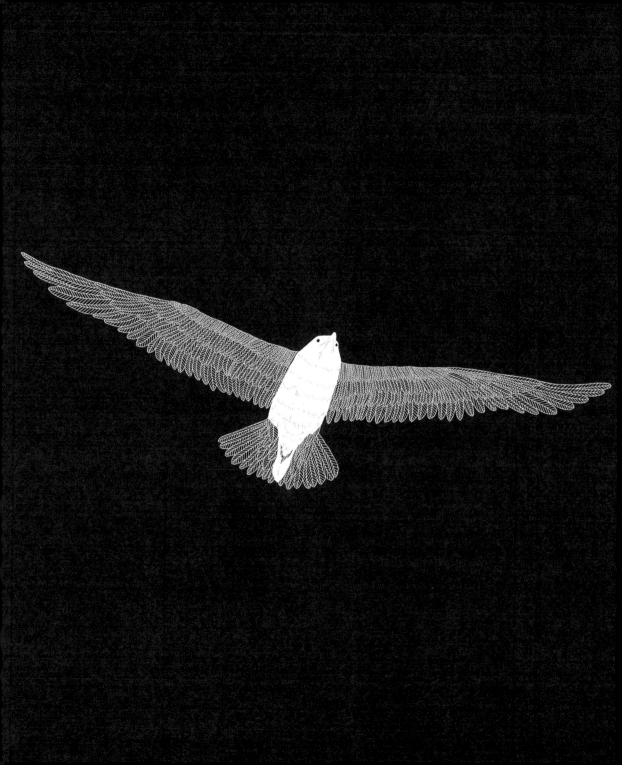

the seagull

The seagull shows us the importance of adaptation and resourcefulness. She is one of the most widespread birds in the world, surviving and thriving with both ingenuity and cleverness. Nevertheless, she is judged harshly for the very same reasons that make her so successful as a bird, often being called troublesome, pesky, and annoying instead of intelligent, resilient, and fearless. Dear one, respect her strength. She is showing you how important it is to keep going, how important it is not to let the judgment of others stop you from doing what you need to do to survive. Take advantage of all that may arise and do not let others judge you for acting on the opportunities that are presented to you. Try not to be held back by the hesitance or misconceptions of others. We must all operate by our own special and unique sets of rules in order to thrive.

the hermit thrush

Your voice is an instrument. Sometimes the smallest bodies, the shyest personalities, possess the clearest and strongest voices. The hermit thrush knows this. Although tiny, rarely seen, and shy, the hermit thrush still manages to leave a lasting impact on the world through the haunting purity of her song. Learn from the hermit thrush, brave bird. Even if you feel invisible, your voice can still be heard if you use it. Even if you feel too vulnerable to show the world your physical body, have courage and resilience. Your voice can still be used to gladden and strengthen the world. Keep singing.

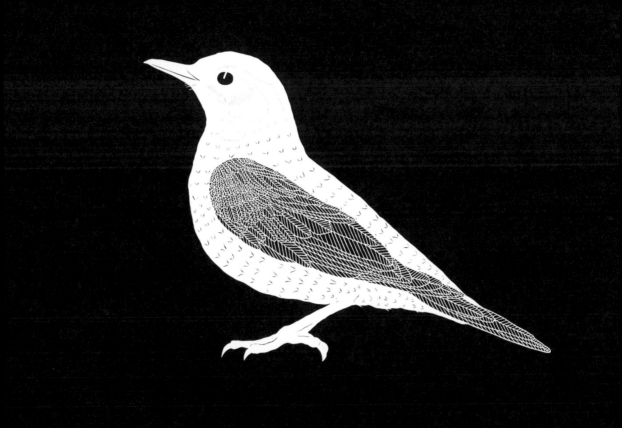

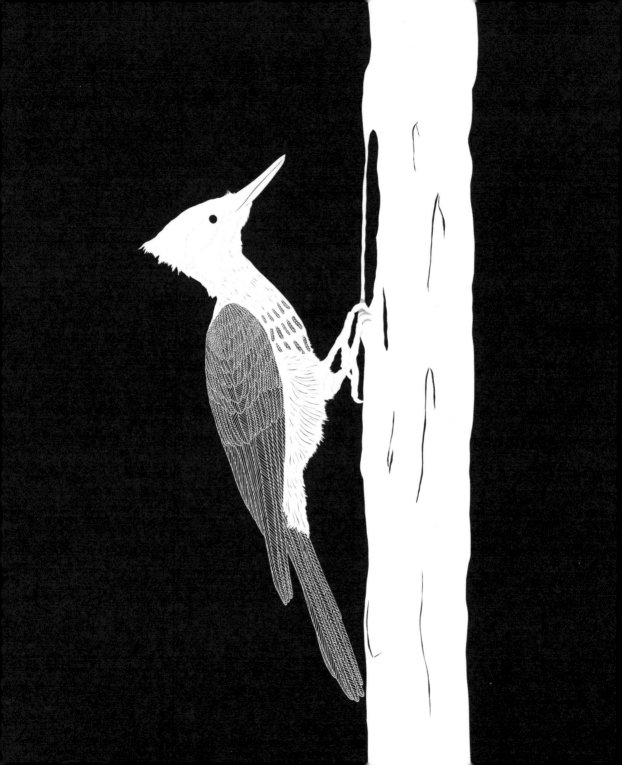

the pileated woodpecker

Sometimes the difficulties may seem insurmountable, dear heart, but keep going! Keep hammering away. The pileated woodpecker knows the value and importance of perseverance. She hammers her holes with patience and determination. There is a lesson to be learned from her careful and dedicated attention. Repetition and rhythm offer us ways to anchor ourselves in the present. Respect and embrace this moment, dear one. Do not be drawn into fear or anxiety over things that cannot be changed or mended. Allow yourself to exist as you are and face each difficulty as it comes with self-awareness and strength. Remember, life is made up of small and mundane moments as well as great, exciting ones. Both the small and the big have their place and both have their gifts to give. Lastly, the woodpecker offers us a lesson of caution: Do not confuse stubbornness with perseverance. Ask yourself what you are striving toward and why.

the pigeon

The pigeon is one of the world's great travelers. She traverses vast distances, unled and unprotected in her journey to return home. She has great gifts of navigation, resilience, and self-confidence. To learn from the pigeon, we must first acknowledge and understand what home is. What does home mean to you, brave bird? Is home a place, a feeling, or a loved one? Is home the smell of your favorite food or the reassuring view of a familiar mountain? The meaning of home is different for each one of us. Explore and embrace your home, brave bird, whatever or wherever home is. That way, however far you may wander, you will always be able to return there.

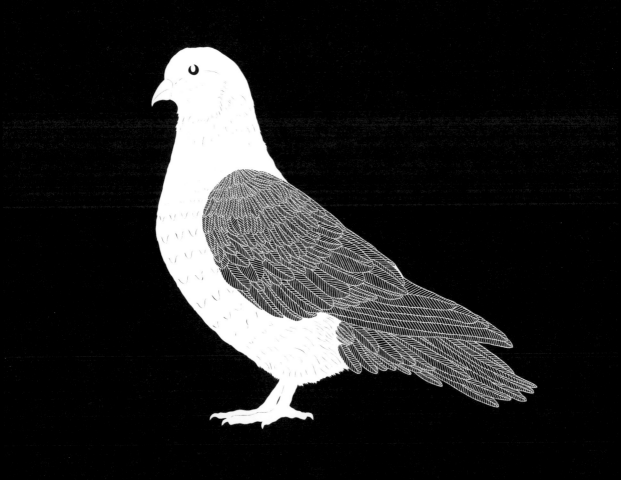

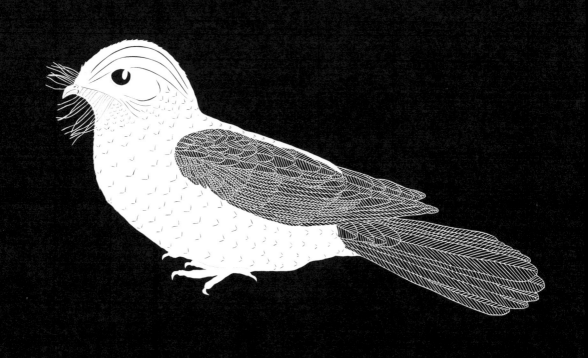

the whippoorwill

The whippoorwill can be heard after nightfall and again just before the sky lightens with the coming dawn. She marks both the falling and the lifting of darkness, a cycle that can be both comforting and at times overwhelming in its ceaseless observance of the passage of time. The whippoorwill's voice is a chant that honors and releases the day that has passed and welcomes and invites the day to come. Have you released yesterday, brave whippoorwill? Do you welcome tomorrow fresh and new and unburdened with the cares and anxieties of the days that have come before? It is important to consciously let go of the past. Do you have words or actions set in place to do so? You have a voice, dear bird. Make sure you are using it to foster your own resilience and to lead yourself into a new day.

the bar-tailed godwit

Every year the bar-tailed godwit migrates incredible distances. She flies over mountains and great oceans, through storms and dangerous weather. For her, there is no such thing as being landlocked. Her yearly migration is said to be the longest of any bird. Do you sometimes yearn to fly away with her, brave one? Her powerful wings free her from the geographical limitations that tether us, her human sisters. She can escape what pains her. Oh, her possibilities are endless! Dear godwit, do not become landlocked at heart. Do not become chained to outdated patterns of life if you feel they are holding you back. Your wings are powerful. Never doubt that they will take you many places throughout your life.

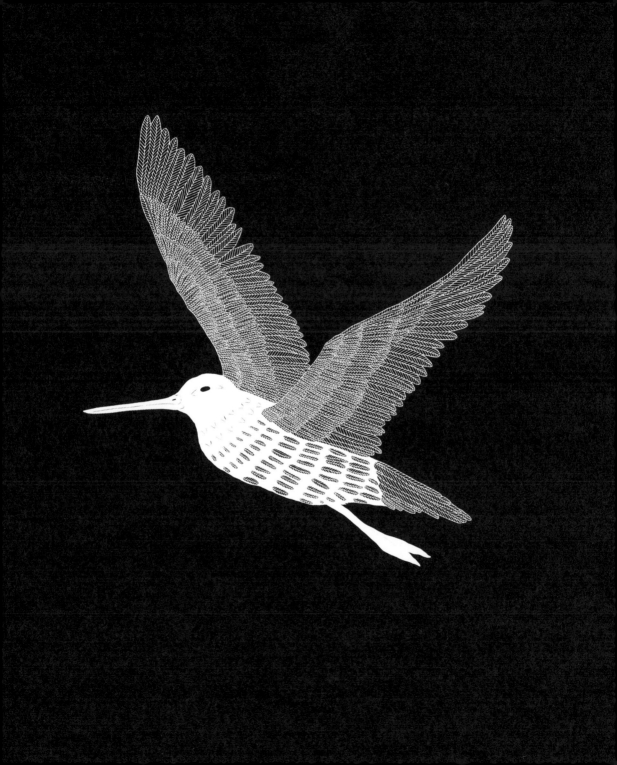

6 | BIRDS *for* COMMUNICATION

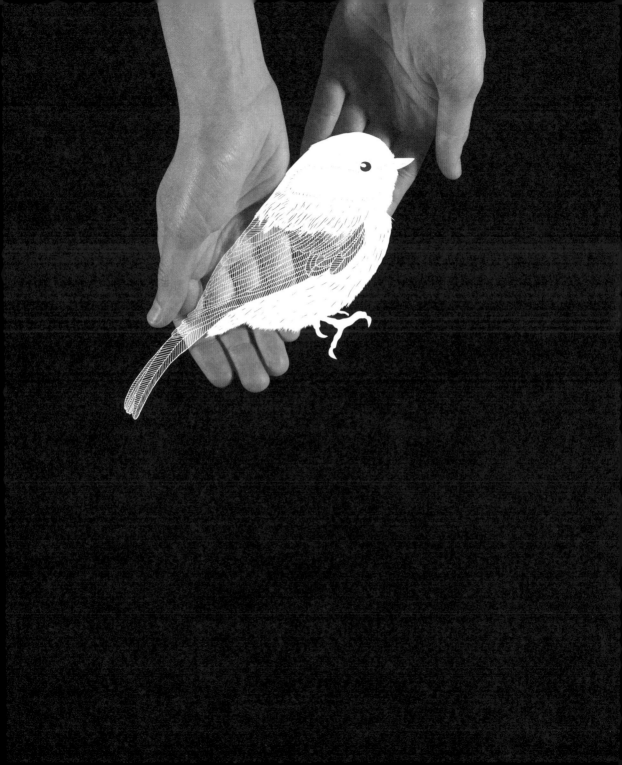

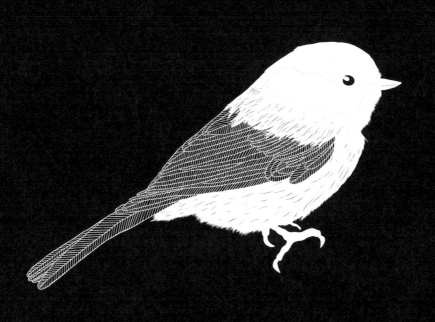

the black-capped chickadee

Brave one, have confidence and rejoice in all of the new adventures you can experience and communicate to others. The black-capped chickadee has a complex language system that makes use of syntax to create calls that impart detailed and specific information on all those who enter and impact his environment. He often becomes a voice for other birds who follow him and stay near in order to listen for his warnings. He knows how to share information and how to spread good news, but he must also be sure to protect himself from giving too much. Brave one, are you expending all of your energy being a voice for others? Have you forgotten how precious it is to return to yourself? May you communicate *your* needs, as well as the needs of others.

the nightingale

Recognize when your voice can and cannot be heard. If you are afraid no one is listening to your words, ask yourself whether this is because others are speaking already. The nightingale sings during the day as well as the evening, but he often cannot be heard until dusk when all of the other songbirds become drowsy with sleep. He knows that twilight is his time to be heard and to share his song. Embrace the gift of civil discourse, brave nightingale. Show others how to be patient and how to take turns listening and speaking. Always be conscious of the messages you give. Open up dialogues that are loving and joyous, not angered or divisive.

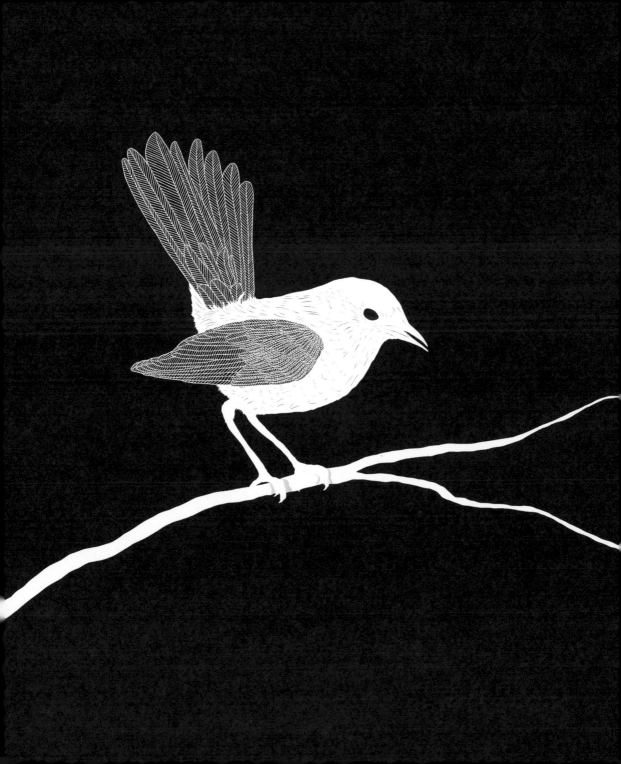

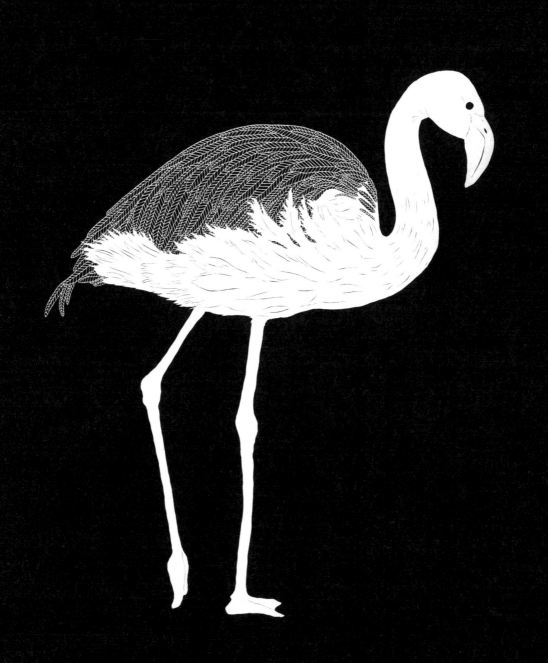

the flamingo

The members of a flamingo colony all attempt to court and breed at the same time, enjoying synchronized and stylized mating dances and behaviors. Are you on the same timetable as your friends? Are your priorities similar? There may be times when you will find yourself feeling left behind or too far ahead, dear bird. Be patient and recognize that there will always be differences between yourself and others, as well as similarities. Both your differences and similarities can lead to richer and deeper dialogues and relationships with others. It takes skill and grace to walk in step with others as well as on your own.

the starling

It is important to maintain contact with others. The skillful starling can teach us the magic of sticking together. Every evening before settling to rest, starlings form murmurations, large and fast-moving flocks that fly close together as they patrol their territory. In these complicated dances, each starling senses and recognizes her seven nearest neighbors and moves with them in intricate patterns. This feat of physical attention is more remarkable than we might think, brave bird. Each starling must be deeply attuned to her neighbors. Watch the starlings, dear. They are showing you that there are many different ways and opportunities to find strength with others. You have the power to communicate and learn both verbally and physically. Remember, there is safety in numbers. We are stronger together.

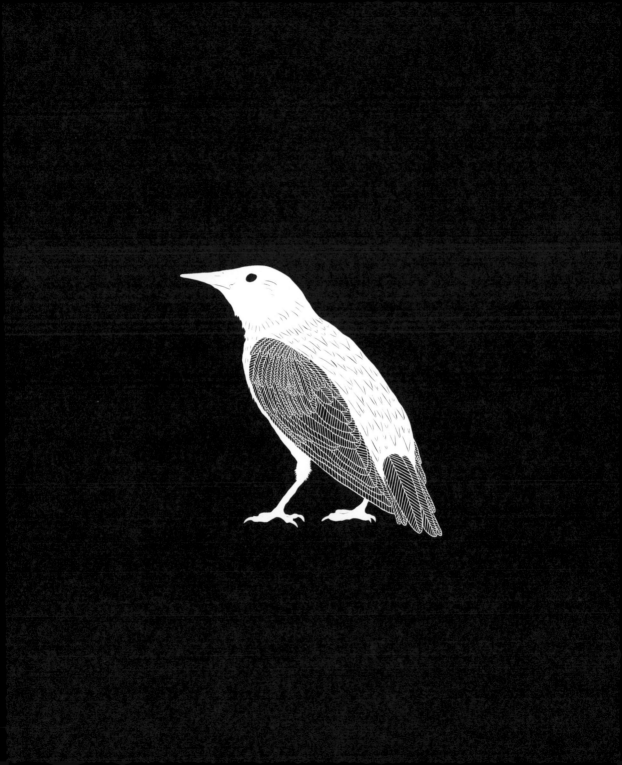

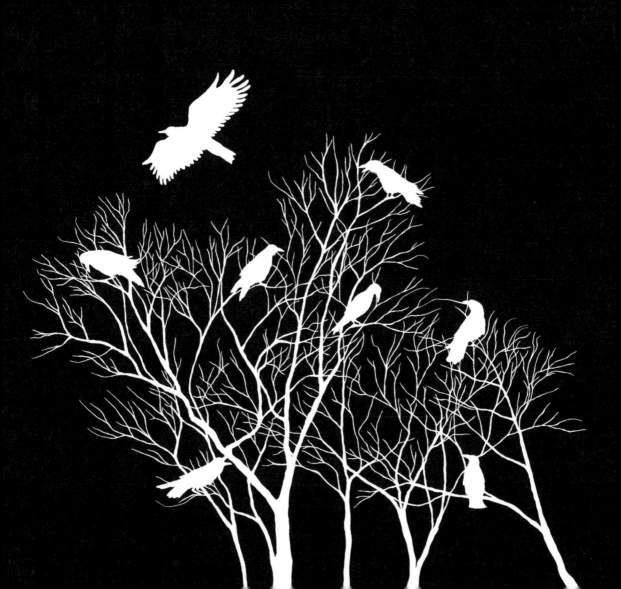

the new caledonian crow

A New Caledonian crow has the ability to study and learn from others and to teach and pass on her own knowledge. This is a great gift, dear one. Throughout her lifetime, she will watch and learn how to craft tools. As she matures, she will observe, create, and experiment until her own tools become useful and unique enough to carry with her. What tools have you been taught that you can carry with you, brave crow? Never forget how important it is to keep learning from others and innovating and reshaping your mental and emotional toolkits.

the superb lyrebird

The male superb lyrebird's magnificent train of feath-
ers is remarkably beautiful and cannot escape notice.
At first glance, his female mate may seem dowdy and
plain by comparison. But look and listen closer, brave
bird. Unlike most bird species, both the males and the
females sing, being extraordinary and playful mimics of
other birds and ambient noises. Partnerships aren't all
visibly equal in the same way, and beauty isn't just about
physical appearance. Beauty can be found in a voice, in
an idea, in a movement. There are many different kinds
of loveliness. Sometimes, when loveliness is subtle, it is
that much more precious because it takes time to truly
appreciate and grasp. Don't be hasty and write yourself or
others off, lyrebird. Some beauties are bigger and more
magnificent than can be understood at first glance. It
takes time and willingness to listen and observe to truly
appreciate the depth of what you offer another creature,
and what they offer you. May you surround yourself with
those who appreciate the gifts you give.

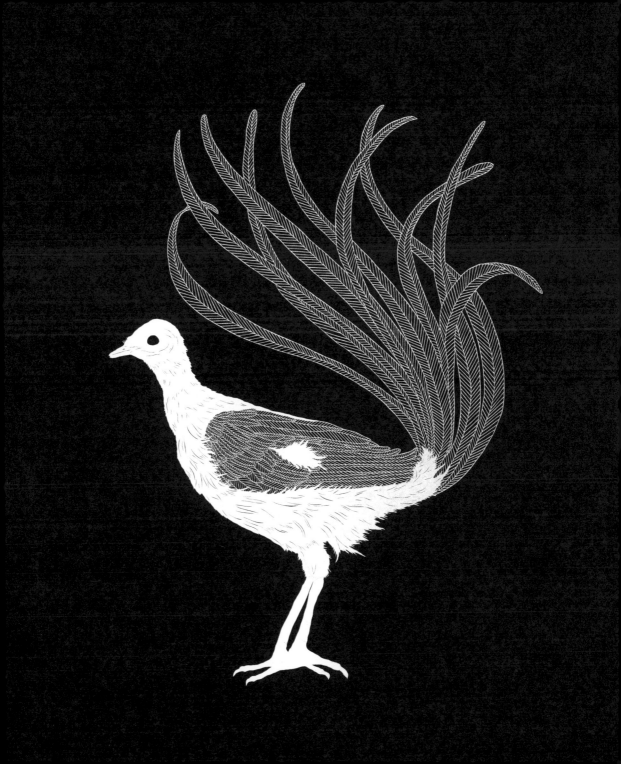

7 | BIRDS *for* STRENGTH

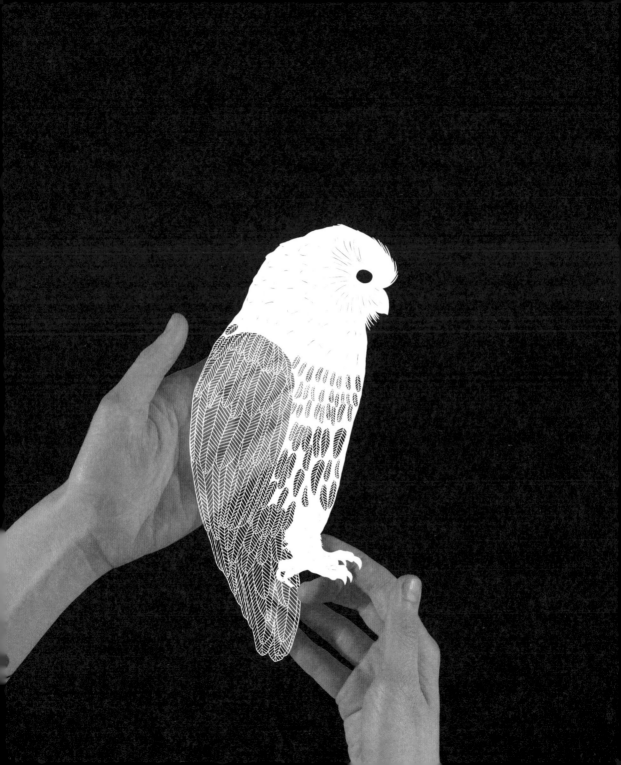

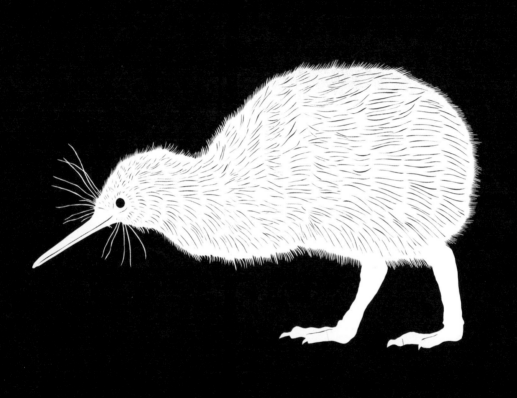

the kiwi

The kiwi is a flightless, nearly blind, nocturnal bird who hunts and navigates by the sensitive touch of her beak and facial bristles. During the day, she nests in her burrow and every night she ventures forth to sense her way in the darkness. Do not be afraid to shut your eyes and do what feels right, brave kiwi. Sometimes instinct must be allowed to lead you in the right direction. Close your eyes. Take a deep breath. You were made to do this.

the ostrich

Make sure you are connected to the earth. Make sure you are grounded. For us human birds, sometimes feeling disconnected from land isn't the healthiest thing. Dear one, there are times when it is best to draw your strength from the earth, from the ground beneath your feet. Let the earth support you. The sure-footed ostrich knows this lesson. She feels the power of the earth and draws her strength from her sturdy legs. If you've been dreaming or worrying too much, perhaps it is time to return to the earth and the mundane and practical side of things. The everyday routines of life can always be depended on to provide much needed structure and safety.

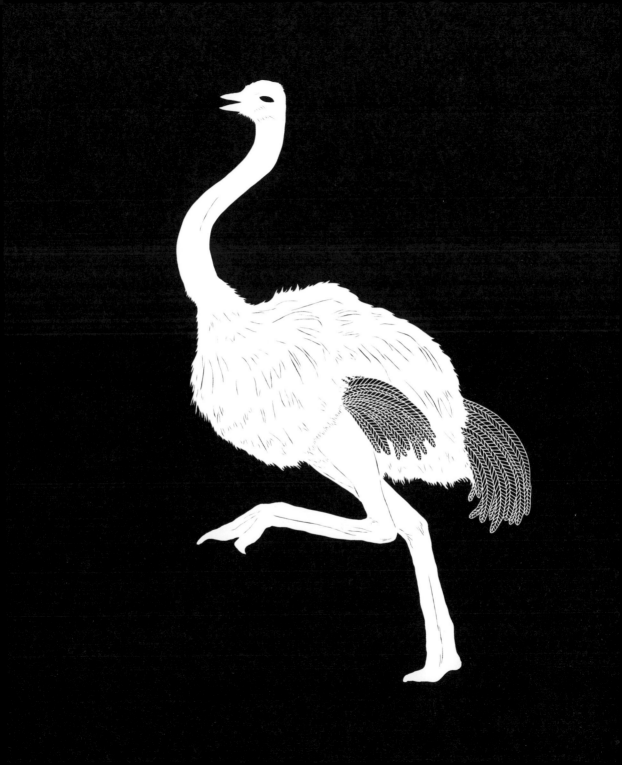

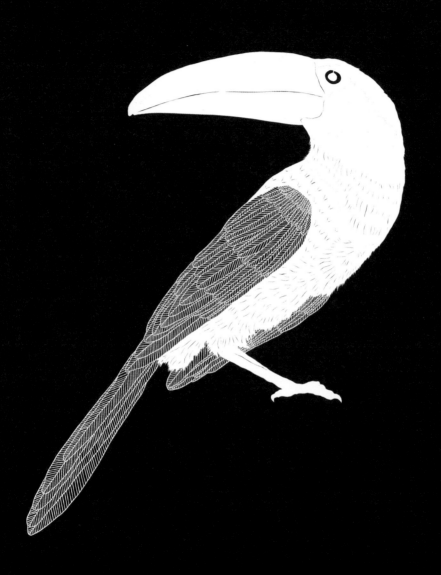

the toucan

The wondrous toucan possesses a uniquely specialized bill. Although her bill can comprise up to half her body size, it is spongy and airy and very lightweight. Dear, the parts of yourself that seem the largest and most cumbersome can also be the most amazing. You were created this way for a reason. Meditate on what you can offer the world that only you can share. Yes, being different can be discouraging and lonely, but it can also be wondrous and comforting because it means that what you offer the world is very special. It cannot be offered by anyone else! Be kind to yourself, brave one. It is through self-kindness that you gain deep strength.

the kingfisher

The kingfisher knows the value of a safe and protected home. Respect yourself and your need for privacy and safety, brave kingfisher. When creating nests, kingfishers can tunnel up to ten feet into riverbanks. Have you made a safe place for yourself to be alone, brave kingfisher? Have you separated yourself from the stresses and fears you face in the outside world? It is important to remember that solitude is not retreat from that world. A need to be alone does not make you weak. Solitude is essential for a balanced and healthy emotional state. You must be kind to yourself. You must treat yourself gently. Never feel ashamed if you need to retreat to your safe space, brave bird. But do not spend too long there or else you may forget the joy and loveliness in the world outside.

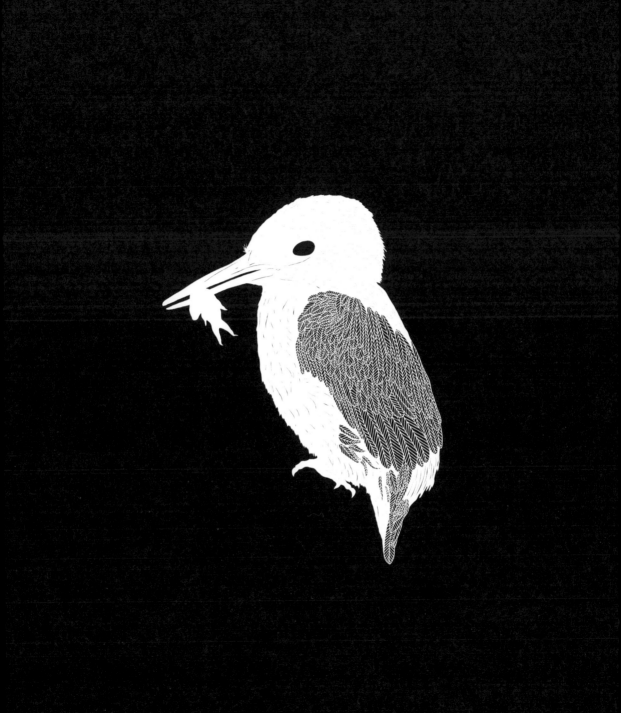

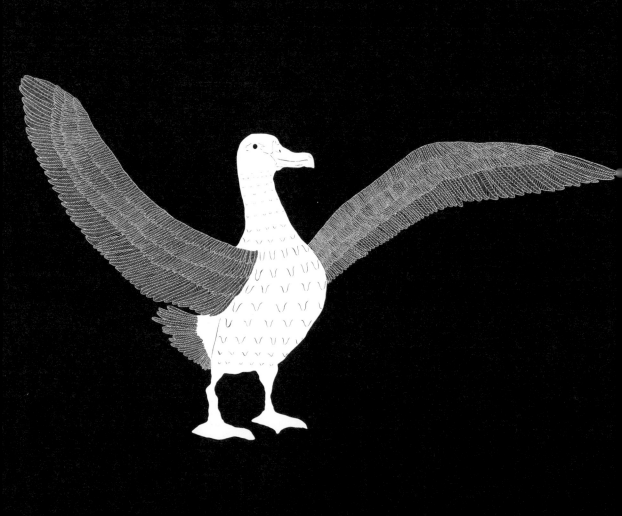

the wandering albatross

The wandering albatross has the largest wingspan of any living bird. Her great size makes it necessary for her to depend on the wind to remain in the air. Be brave, dear one. Extend yourself both mentally and physically, but know that this may take you places others may not have reached yet. You may be alone for a time. Although a wandering albatross will mate for life, she will still spend most of her time alone and in flight. Catch the wind, if it is calling you. Know that sometimes, the wind that we struggle against can be our greatest companion if we simply turn ourselves around and let it carry us forward in a new direction. It takes great courage and great strength to allow ourselves to travel far and to travel alone.

the secretarybird

The fierce secretarybird does not hunt from the air as most birds of prey do. Instead, he stalks the desert plains and often kills his prey by stomping on it. He is immune to snake venom and kills cobras, adders, and other dangerous pests. In this way he is able to take on a vital role within an ecosystem. Brave bird, do you have some special strength that can allow you to take on a role that others might find difficult or impossible? Is there some offer of assistance you can make to those who do not possess your unique skills?

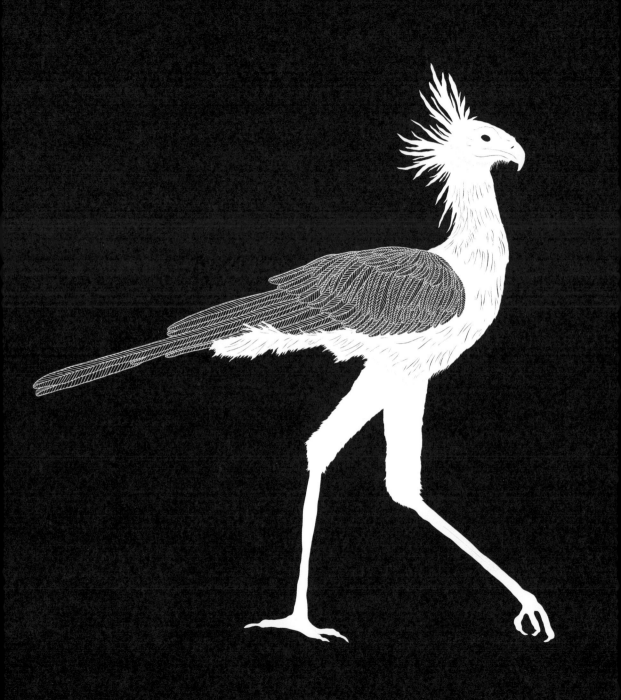

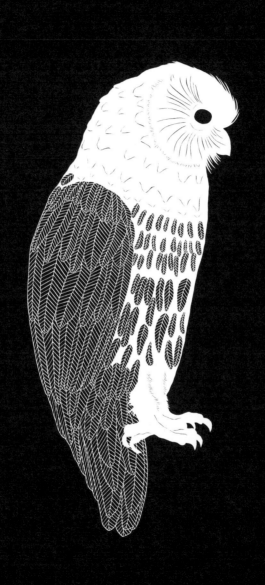

the laughing owl

The laughing owl was one of only two native New Zealand owls. Sadly, she laughs no more. In 1914, the last known laughing owl died. Extensive land clearing by Europeans and the introduction of competing and predatory species caused her extinction. She leaves behind a powerful message for us, dear one. Throughout your life you will find yourself in many different places, emotionally and physically. May you learn to function in more than one environment and with different and competing personalities. Do not allow yourself to be pushed out or set aside, brave owl. Keep going. Keeping laughing. Keep flying.

8

BIRDS
for
AWARENESS

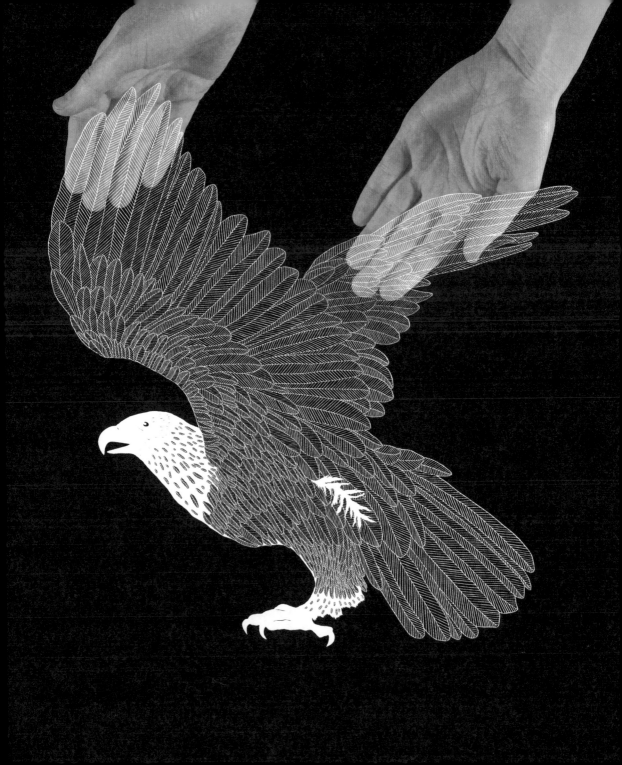

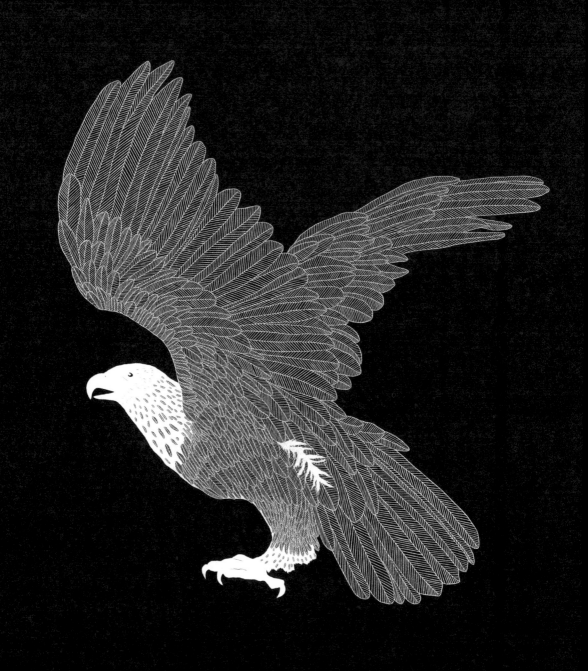

the eagle

The eagle rises to great heights. She can look down on the earth from a vast distance to obtain a different perspective. Like the eagle, you have the power to see in all directions, dear one. You can use both your keen eyesight and your thoughtful insight to see much more than what is immediately before you. You can gaze upon your past, your present, and your future and grow wise. Rise above, brave bird. There is much to see and to learn. From your great height, you will see what needs to be done, and you will know the right moment to do it.

the puffin

A puffin can collect and hold a dozen fish or more in her mouth when diving. Inside her bill are rough barbs that hold the fish in place. But the majority of the fish she catches are not for herself, but are collected to feed her chick. Dear puffin, have you been carrying the weight of others for too long? It can be gratifying and empowering to care for those you love, but do not let these duties swallow you. Do not lose yourself. You may need some time off now and then, in order to stay healthy. Although it may seem hard to grasp sometimes, your health and happiness are just as important as the health and happiness of others.

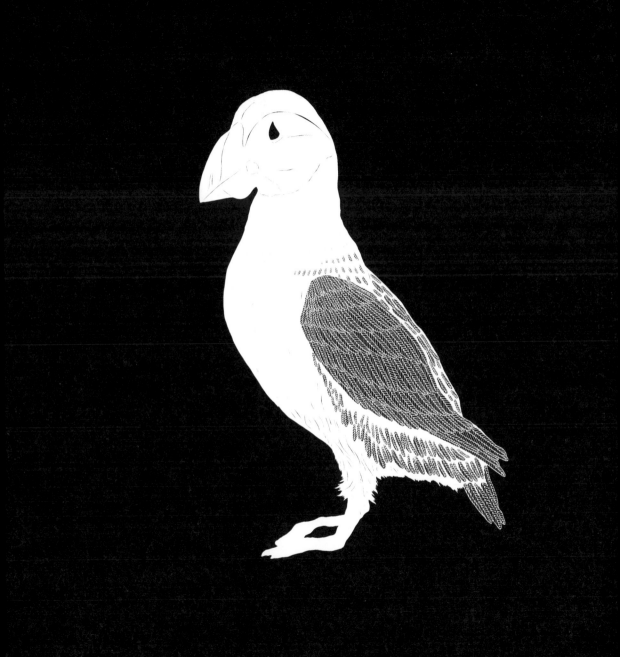

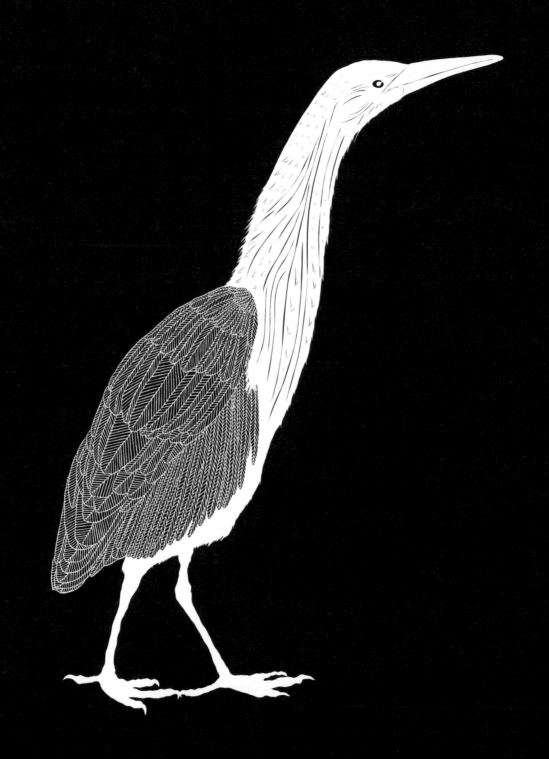

the bittern

When startled or uncomfortable, the bittern stands straight and sways with the grasses that surround her, echoing their movements. This instinct is both a curse and a blessing, brave bird. Do you want to weave yourself into those who surround you or to stand out from the crowd? Your uniqueness may be lost if you mimic others. Are your physical actions merely reflexive and prompted by fear and emotional insecurity? Strive to act consciously—to foster your own emotional well-being. Be aware of your own body and notice what actions your body makes. Do you clench your fists or hunch your shoulders when confronted with the unexpected or the uncomfortable? Be strong in body, as well as strong in mind. I know you have great courage, brave bird.

the swift

The swift is possibly the world's greatest wanderer. She will fly up to four million miles in her lifetime, perhaps the most time on the wing of any bird in the world. She eats, drinks, mates, and even sleeps on the wing. Her body is shaped for maneuverability and quickness. But for all of these gifts she has sacrificed her ability to find solid ground comfortable or even safe. Have you been wandering for a long time in mind or body, dear one? Have you forgotten how to be comfortable in stillness? Remember that the distance you travel is not what defines you. You are still the same strong, courageous bird whether you keep flying or whether you stop and rest. Make sure your wandering ways are not taking you away from truly being yourself.

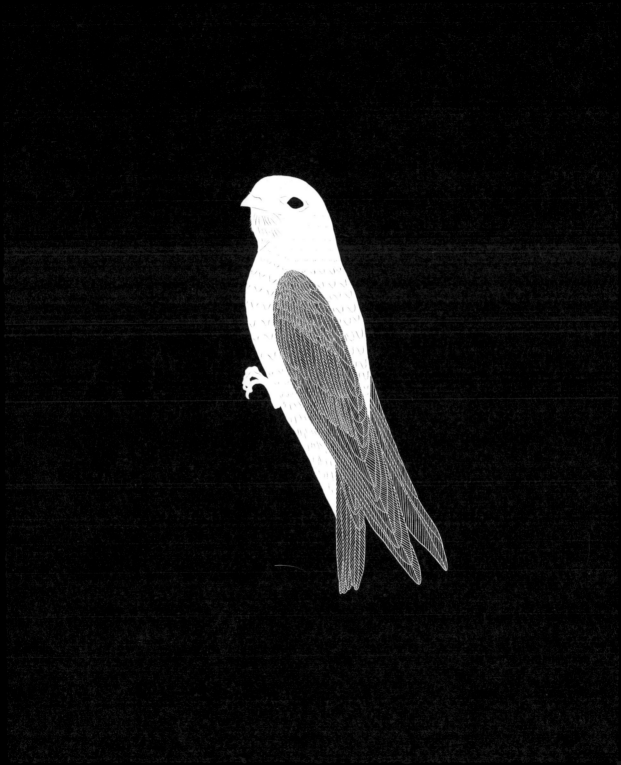

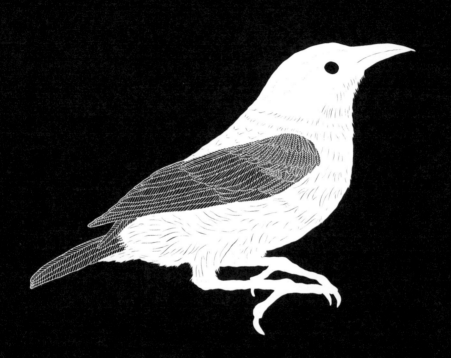

the bananaquit

The bananaquit knows how important it is to have your own private place that belongs to you alone. Both male and female bananaquits construct their own individual nests and live in them separately. Have you created your own special space, brave bird? It is important to respect and nurture your own identity as well as the identities of others. When strong people share homes or relationships, misunderstandings can often occur. Make sure you do not share everything with others, brave bird. Be conscious of your own need for freedom and self-expression.

the great horned owl

The owl is a night hunter. Her wing feathers are uniquely created for silence and speed. Even the keenest ears cannot hear her passing. Honor and value your silence and your darkness, dear owl. Let yourself be still. The darkness can be a time of safety and personal reflection, a time for imagination and awareness. Let the nighttime become your soft cocoon where any dream is welcome. Imagine what is possible when nobody is looking! Remember, it is the owl's flexibility that allows her to see in all directions. Relax, dear one, and open yourself to all that is achievable.

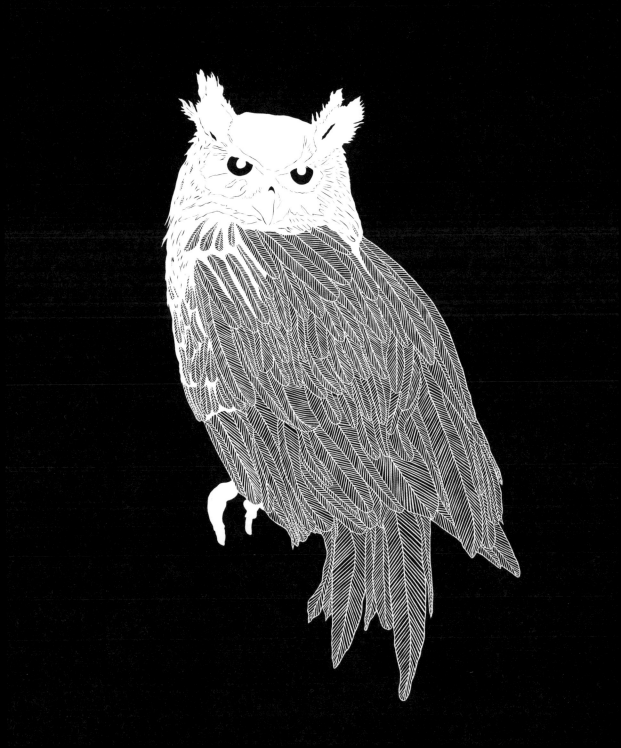

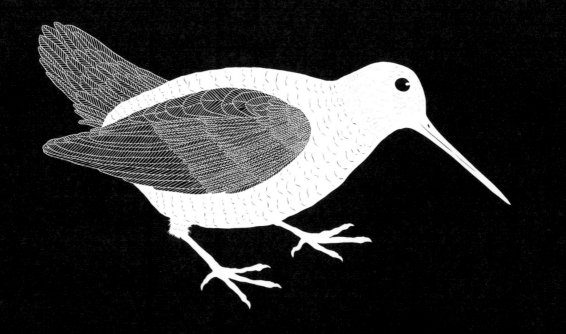

the woodcock

Take a step back so you can see the big picture, brave bird. Don't worry about the details. The shy, observant woodcock has large eyes that are set high and far back on her head. She has the ability to see 360 degrees ahead and behind her and 180 degrees above. She is believed to have the largest field of vision of any bird. Do you feel the need to learn from the woodcock, brave bird? Perhaps the time has come to stop worrying about the small stuff. Instead, turn your mind to bigger questions. You may find that when answered, your big questions will solve a multitude of little worries as well.

9 | BIRDS *for* ACTION

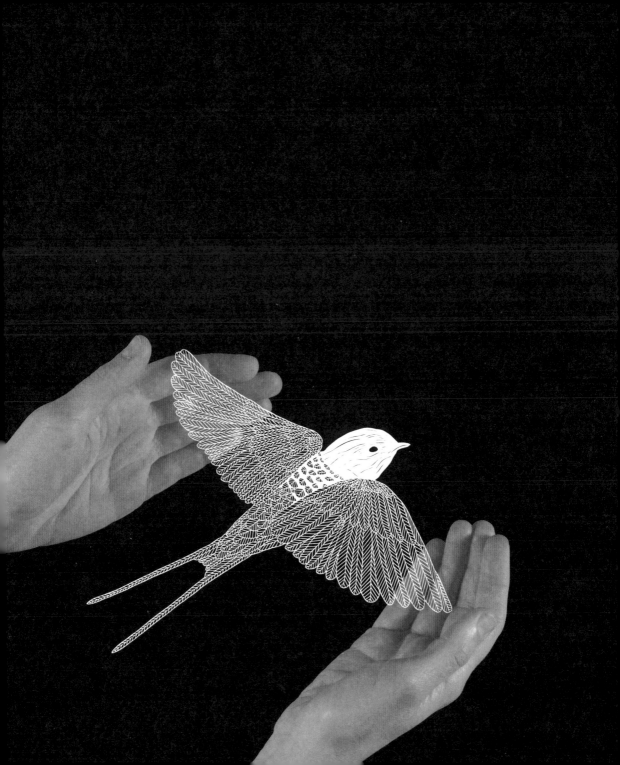

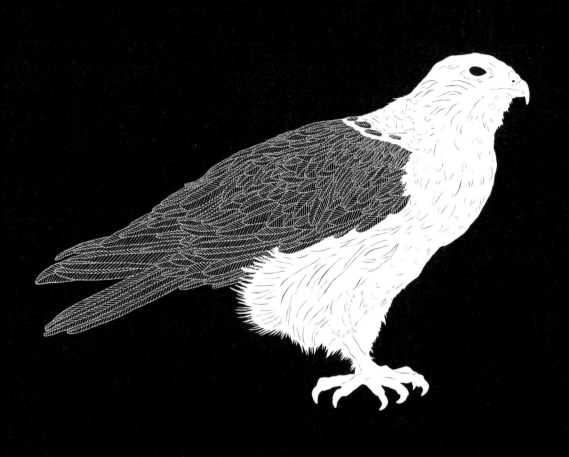

the hawk

Try not to let yourself be swayed by self-doubt, brave one. When the hawk dives, she does so with complete assurance in her ability to capture her prey. Dive into the wilderness and capture that idea, that object, that important person's attention. You are ready. You have been circling long enough. Trust yourself. The hawk is not an ambivalent creature. You have work to do, dear heart. Rest assured, you have the clarity and power to do this work well. Honor and recognize the intelligence and power that you hold in your body and in your mind today. Take the plunge.

the killdeer

The need to protect can be a powerful instinct. A killdeer mother draws predators away from her young by pretending to be injured. But her wish to protect her young isn't done consciously. She doesn't think her actions through. They are hardwired into her very being. Sometimes our first instincts and our first actions can be proven wrong. Recognize when you are being led by instinct and when you are being led by common sense, brave bird. Appreciate the advantages and the gifts of both, and learn which situations require instinct and which require deep thought and sustained planning.

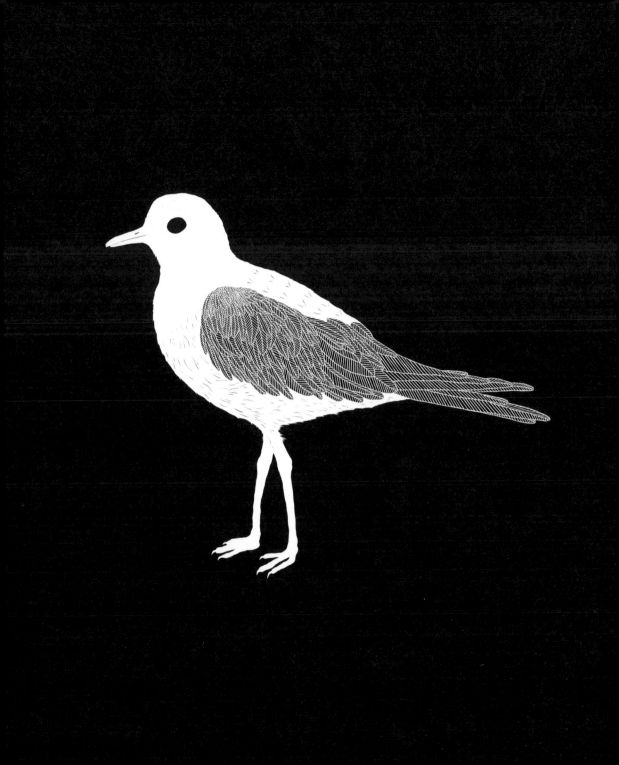

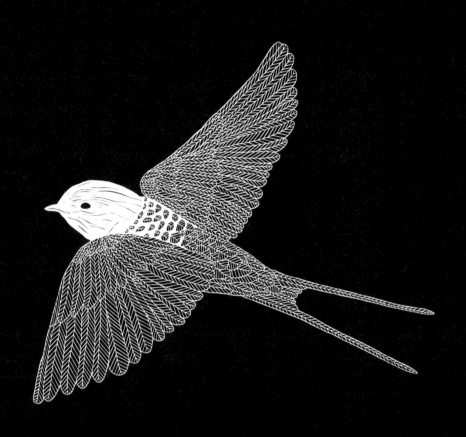

the swallow

Have you ever watched a swallow in flight? Have you ever worried how she can sustain herself, flitting back and forth without rhyme or reason? Have no fear, dear bird. She knows exactly what she is doing. Every random spiral and seemingly aimless soar is merely a search for food. As she flies, she catches insects and bugs in her mouth and feeds on the wing. Do not exhaust yourself with fruitless effort, dear one. You need only do what is necessary. You need not be active just for the sake of it. Make sure your actions have goals and endpoints.

the kestrel

Is it time to make a big decision, brave bird? Before you decide, stop a moment and think ahead. Like the hummingbird, the kestrel is one of the only birds who has mastered the ability to hover in one place without beating her wings. She is a swift and aggressive hunter, yet she is also capable of mastering great stillness and patience. She asks you not to act rashly. Stop, assess, and examine before you act. It can be wise to have a plan.

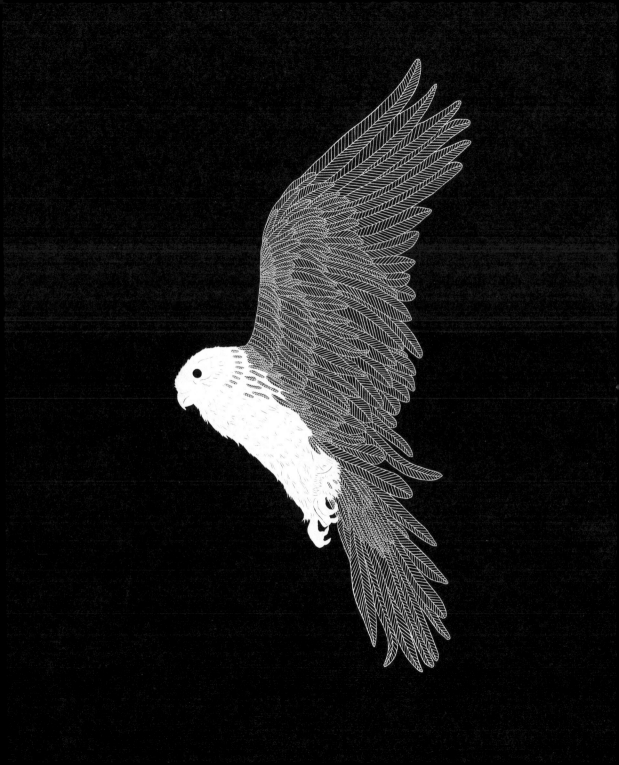

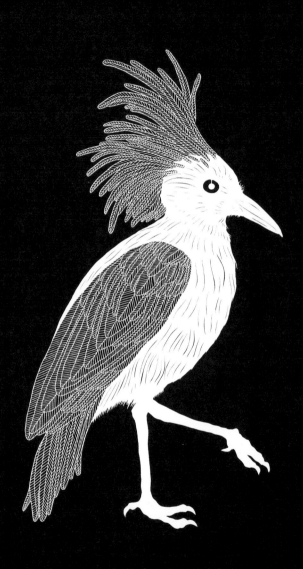

the kagu

The kagu is a bird of the earth. White and ghostly, she lives on the forest floor. She lacks the ability to fly, historically having no need to escape predators on her native islands. Today, with the human introduction of wild dogs and cats, she is critically endangered because she cannot use her wings to escape when threatened. She shows us the importance of both expansion and caution. Like her, have you been given the opportunity to take a chance and move into a new niche? Is it time to expand and take advantage of new opportunities? Have courage, brave kagu, and make your move. But do not overspecialize or forget what served you and kept you safe in the past. Have foresight and be flexible. Make sure to think and look ahead.

the mousebird

Have you been sitting still and thinking too much, dear one? The mousebird speaks to us of the importance of physical activity. Skillful and sociable, she uses her strong feet to scurry along branches and dangle acrobatically upside down, sometimes even feeding that way! Put your thoughts aside and let your mind focus on your physical body. Let yourself be active and allow yourself to exist in a purely physical sense. Do not become overwhelmed by the thoughts circling in your head. Never forget how important it is to take time for yourself to recharge. Sometimes, all you need to become inspired is the opportunity to look at a problem from a new perspective (even upside down!). You can always come back to what needs solving, I promise.

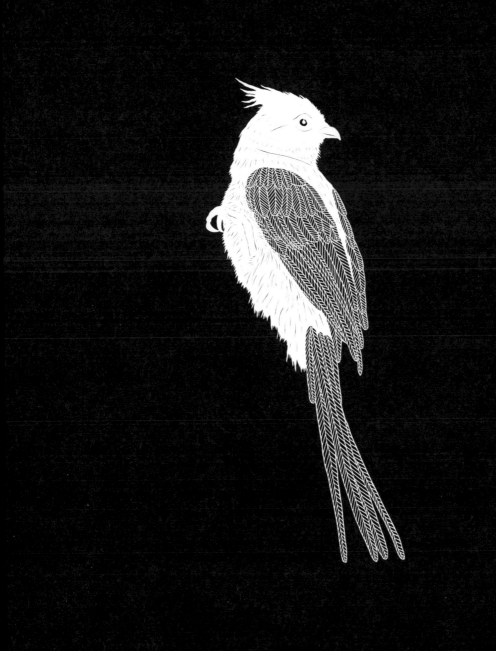

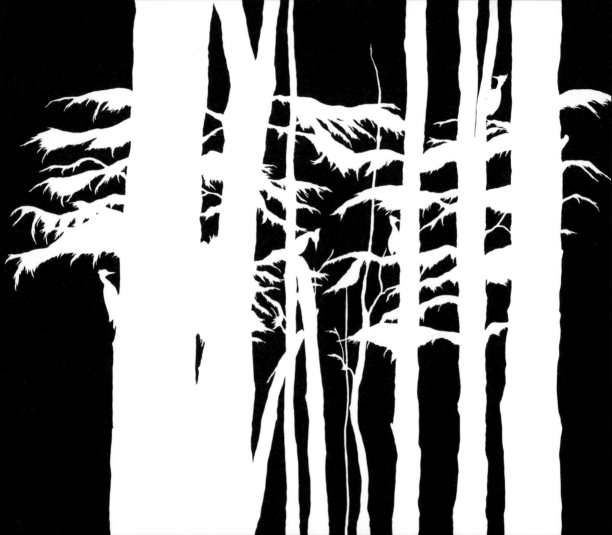

the ivory-billed woodpecker

Never give up hope, brave bird. Never stop fighting. The last confirmed ivory-billed woodpecker sighting was in 1986. Land clearing and habitat loss led to his swift decline during the 1800s and the early twentieth century. Nevertheless, there are many who still believe he is alive today. Land has been set aside and protected with the hope that he has survived. Every year, scientists embark on long, arduous searches into the Southern swamps and bayous to find and protect him. Although they have so far failed, he has not yet been declared extinct. Do not wait to do the right thing, brave friend. There is always room for hope. Never stop believing that someday you will find what you're looking for. It is never too late to do what needs to be done.

10 | BIRDS *for* TRANSFORMATION

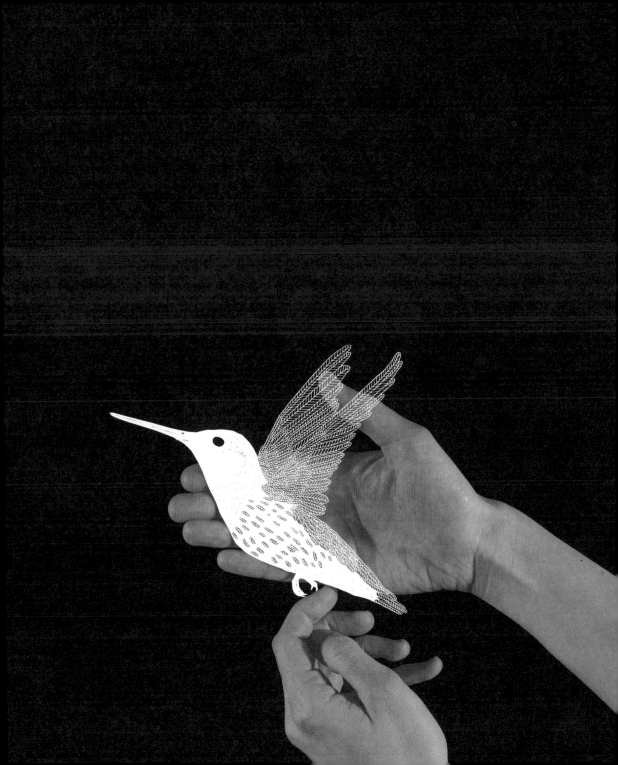

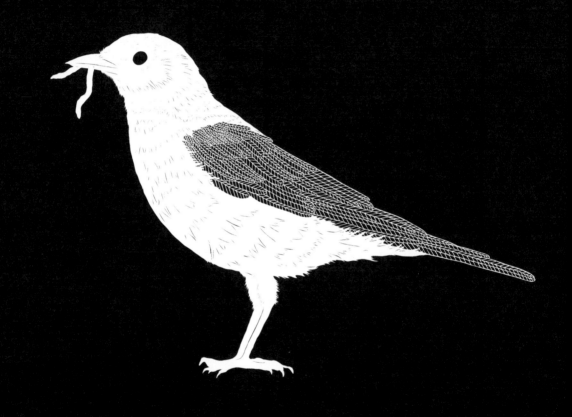

the american robin

Have you heard the call of spring, brave bird? Is there a strange, joyous song on the early morning air? Listen closely! How precious is this new phase of growth! The robin travels north every spring to breed. She is often the first migratory bird to appear as the earth begins to warm and the days begin to lengthen. Soon, new tender shoots will begin to grow and trees will bud. Dear bird, is it time to grow intellectually, creatively, or imaginatively? Perhaps the robin is giving you a sign. Remember that every spring the world is born anew. Make sure you mark this new phase of life.

the hummingbird

The hummingbird possesses the gift of infinity and timelessness. She is the only bird whose unique figure-8 wing-beat allows her to hover in midair and to fly backward. You possess this gift as well, dear bird. You can fly backward into your past, examine what has come before, and learn to move forward from it, all while still recognizing that the past is the past. The hummingbird teaches us the importance of presence, while showing us that we also have power over what has come before. You have power over what you remember, brave hummingbird. Never forget that. Choose to remember what is beautiful. You can live in the present moment, acknowledge its joys, and also remember and embrace what you have already experienced.

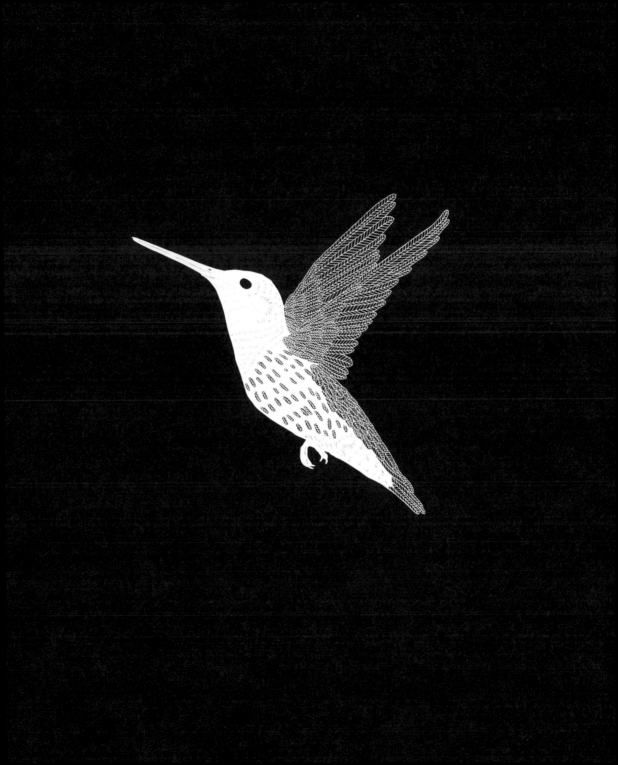

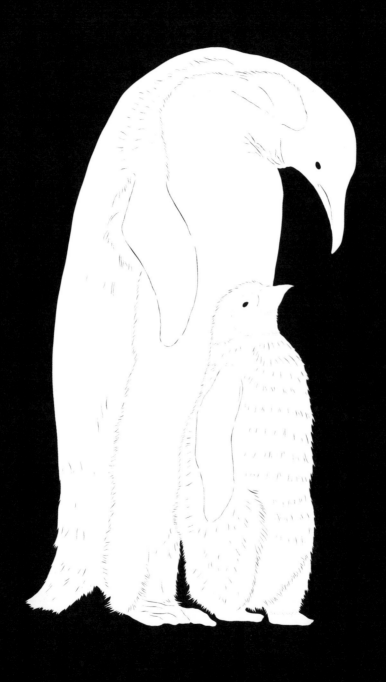

the emperor penguin

The male emperor penguin possesses the gift of flexibility and openness. Each breeding season, he raises a fledgling alone, without help or interference from his mate. This unexpected but vital nurturing role shows us the joy to be found in taking on and embracing new or traditionally unacceptable positions in society. Let yourself be guided by openness, dear heart. Know that there are many roles you and others may take on in life, and that there are many opportunities to explore and grow. You do not need to take on the role that society has given you. You may choose for yourself. It is exciting to learn and explore new avenues toward expansion and adventure.

the marbled murrelet

The marbled murrelet is a mysterious and courageous water bird capable of teaching us many lessons. She nests in old growth forests, on a mossy branch more than one hundred feet in the air. Every year, she returns from the sea to the same tree, the same branch, to lay one egg. In time, her grown fledglings will do the same. But the forest is changing around her. Soon, her tree may be gone due to elements beyond her understanding or control. Unlike her, you have the power to understand such transformations, brave bird. You can recognize that someday, you may come home to find that things have changed. After all, nothing can remain the same forever. Do not be ruled too much by your concept of what you had before, of what home used to be. Do what you can to see the good in the new. We change, just as our environments do, and there may come a time we will find ourselves outgrowing what we had before. Dear one, there is nothing wrong in that. I know that you will find a place where you fit in.

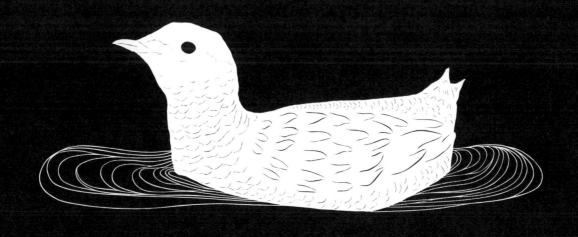

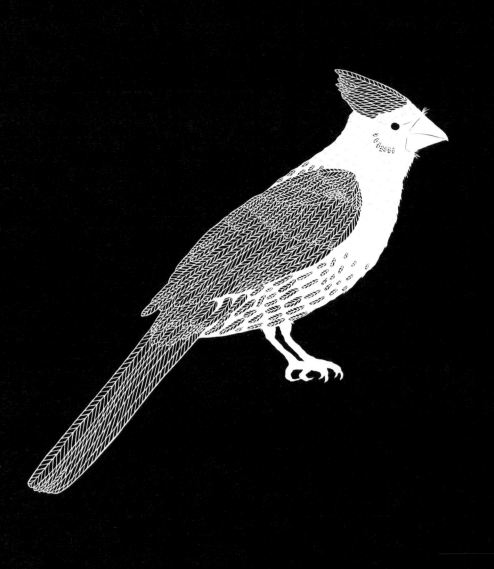

the cardinal

The cardinal knows how to be fierce. She works diligently, sometimes exhaustively, to protect herself from danger. But alongside her protective instinct runs an equally strong inability to recognize her own face and body in windows or reflective surfaces. More often than not, she attacks herself. Dear one, you are not your own enemy. Do not be hard on yourself. Instead, learn to transform your fierce instincts. One can love fiercely. One can be fiercely kind. Redefine what it means for you to be a fierce creature.

the snow goose

Zugunruhe is German for the yearning for change and movement that comes every autumn when the world darkens and winter approaches. Every year, the snow geese fly south in V-shaped flocks, their wild calls a message, an affirmation that change and transformation are necessary and healthy. Have you heard the geese calling, brave bird? Perhaps they are telling you that it is time to enter a new season in your life. The snow geese remind us that like the seasons of the year, all difficulties move and transform. In time, they all pass on and are reborn, new and different. Are you paying attention to the signs this new and glorious season is showing you?

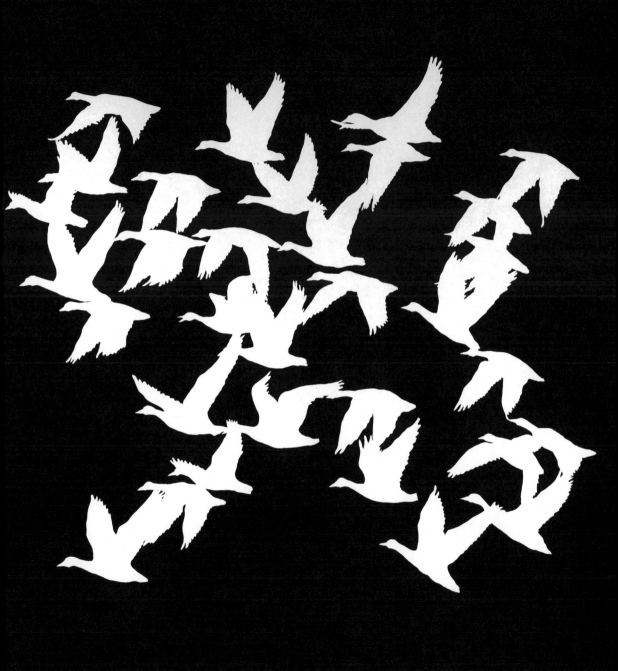

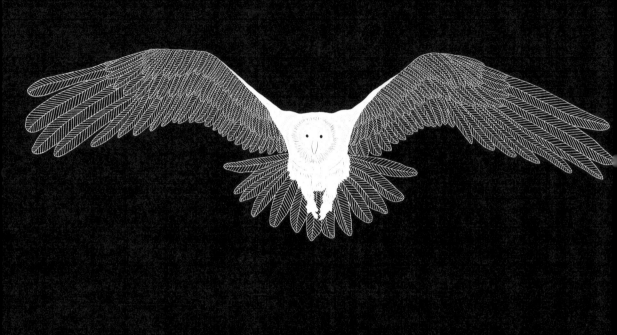

the bearded vulture

The bearded vulture fills a role in the environment that is feared by many other creatures. This role makes her both wondrous and strange. Her diet consists almost entirely of bone marrow, and as such she is intimately connected to death. By transforming bone into sustenance, she presents us with the uncomfortable reality of our own mortality. She reminds us that we will all decay into the earth. She asks us to confront taboos and our own instinctual prejudices. After all, a bird who eats bones could be deemed forbidden and unnatural. Do you need to release prejudices like this, dear one? Do you reject what causes you discomfort out of fear? Even the bearded vulture has her part to play in the world. She shows us that sometimes, even death can lead to transformation and the spark of new life.

ACKNOWLEDGMENTS

This book would not have been possible without the presence and patience of my family. My mother's dear companionship and creativity. My father's love for words. The kindness and warmth of my sisters and brother and of Francie. I am so honored to call them family. My dear friend and agent Joan whose infinite encouragement and wisdom has given me hope and passion. Laura, who gave me the gift of her time and her immense talent. Camaren and Karrie and Abrams for giving me this incredible opportunity to share my birds. Thea, Mariah, Gilbert, Catherine, and Alexx, who always feel close to me no matter how far away we are. Special thanks to Jesse Gordon whose bird photos inspired and moved me. To Cort, who led me to this place. And thank you to all the birds. I hope we can remain here together for a long time.

Editor: Camaren Subhiyah
Production Manager: Rebecca Westall

Library of Congress Control Number: 2017949394

ISBN: 978-1-4197-2909-6

Text and illustrations © 2018 Maude White

Cover © 2018 Abrams

Printed and bound in China
10 9 8 7 6 5 4 3 2 1

Abrams books are available at special discounts when purchased in quantity for premiums and promotions as well as fundraising or educational use. Special editions can also be created to specification. For details, contact specialsales@abramsbooks.com or the address below.

ABRAMS The Art of Books
195 Broadway, New York, NY 10007
abramsbooks.com